Hung Liu: *A Ten-Year Survey*
1988–1998

Curators

Thalia Gouma-Peterson
Kathleen McManus Zurko

Editor

Kathleen McManus Zurko

Essays by

Norman Bryson
Thalia Gouma-Peterson
Dave Hickey
Allan Kaprow
Hung Liu

**An exhibition organized
by The College of Wooster Art Museum**

Published by
The College of Wooster Art Museum
R. Stanton Hales, President

Library of Congress Catalog Card Number:
97-69290
ISBN 0-9604658-9-8

Fifteen-hundred copies of this
catalogue were printed and bound by
The Collier Printing Company,
Wooster, Ohio

Catalogue Design:
Christopher Ransom Design Ltd.,
Kent, Ohio
Photography:
Courtesy Steinbaum Krauss Gallery,
New York, New York; Dallas Museum
of Art, Dallas, Texas; National
Museum of American Art, Smithsonian
Institution, Washington, D.C.; and the
Kemper Museum of Contemporary Art,
Kansas City, Missouri.
Photographers:
Ben Blackwell, catalogue numbers
11, 16, 17, 19, 20, 24, 26 and cover;
Brent Wahl, 13, 23; Noel Allum, 12;
Adam Reich, 9, 15, 18; Tom Jenkins, 2.

Cover:

Five Eunuchs, 1995 (detail)
oil on canvas, mixed media
70"h x 96"w x 4"d
Collection of
Bernice and Harold Steinbaum,
New York
Courtesy Steinbaum Krauss Gallery,
New York, New York

Hung Liu: *A Ten-Year Survey*
1988–1998

Exhibition Itinerary

March 27 - June 7,
1998

The College of Wooster Art Museum
Ebert Art Center
Wooster, Ohio

August 26 - October 19,
1998

Muscarelle Museum of Art
College of William and Mary
Williamsburg, Virginia

November 7 - December 27,
1998

Kemper Museum of Contemporary Art
Kansas City, Missouri

January 24 - March 16,
1999

University Art Gallery
University of California, San Diego
La Jolla, California

April 8 - June 6,
1999

Bowdoin College Museum of Art
Brunswick, Maine

September 19 - November 28,
1999

Ackland Art Museum
The University of North Carolina at Chapel Hill
Chapel Hill, North Carolina

•

We are grateful to Hung Liu for sharing her art and her life with us, for patiently and enthusiastically answering numerous questions, and for letting us visit with her in her home and studio in Oakland, California. This exhibition, and our friendship with Hung, have enriched our lives.

We thank Bernice Steinbaum for her staunch support and collaboration throughout this project. Joanne Isaac deserves special recognition for her assistance, for without the help of the Steinbaum Krauss Gallery and its staff, this exhibition could not have taken place.

To Norman Bryson, Allan Kaprow, and Dave Hickey, we extend our appreciation for their contributions to this catalogue. Their essays provide challenging, refreshing, and diverse perspectives on Liu's work. Jeff Kelley, Liu's husband, we thank for working with the artist on the compilation of the chronology. Carl A. Peterson, Linda C. Hults, and Donna K. Warner we thank for their editorial counsel, and Christopher Ransom, for the design of this catalogue.

For making this exhibition possible through the loan of their painting, or in some cases paintings, to this exhibition, we thank the following individuals, galleries, and museums: Penny and Moreton Binn, Aaron and Marion Borenstein, Rena Bransten Gallery, Dallas Museum of Art, Barbara and Eric Dobkin, Nancy and Peter Gennet, Hung Liu and Jeff Kelley, Kemper Museum of Contemporary Art, Steinbaum Krauss Gallery, National Museum of American Art, Smithsonian Institution, San Jose Museum of Art, Frances Elk Scher, Ellen and Gerry Sigal, Bernice and Harold Steinbaum, and Esther S. Weissman.

Finally, we acknowledge the generous support of the National Endowment for the Arts and the Ohio Arts Council, both of whom made the catalogue, exhibition, and national tour of Hung Liu's work possible. We hope that the catalogue and exhibition are worthy testimonies to the essential role the NEA and the OAC play in the creative life of the United States and the state of Ohio.

Thalia Gouma-Peterson
Museum Director

Kathleen McManus Zurko
Curator

●

How do widely different cultures (such as China and the U.S.A.) misunderstand and understand one another? Especially when their contacts rarely come about in benign fashion?

Every answer must be unique, of course. Hung Liu incorporates in her artworks abrupt juxtapositions of early twentieth-century photographs taken by Westerners for Western use, and by Chinese for Chinese use—photographs of Chinese daily life such as portraiture and images of prostitutes made for advertising. The poignant ironies of how such images were taken then, and how they are seen today, cannot escape anyone, even when Chinese use and give new meaning to Western modes like photography. A photo of a woman revealing her deformed feet that were bound since childhood implies that she has been immobilized as much by the camera as by social custom.

Taken in balance, Liu's implied cultural critique joins that of much current art in the East as well as the West. While it doesn't pretend to be social science or politics, it does locate itself in an arena of scholarly theories of culture shared by activist artists and critics today.

It's possible to look at an artist's work and form some idea of her personal traits. Liu's "cultural critique," for example, suggests an artist of grave social conscience and serious demeanor. Yet Hung, the human being, is typically filled with robust humor, and reflects a certain detachment rather than heavy judgment. One can say, then, that,

like a Taoist, she sees life's awful absurdities pass by and through her like clouds and raindrops.

When I first met Hung I saw that she was reasonably familiar with Western modernism; what she wanted was to know more about the contemporary vanguard in America. Theories and facts wouldn't do. She had already been an art professor in Beijing. So I said something pompous, like: "American avant-gardism is all about swimming in the throwaway environment." To demonstrate this great truth, a small group of friends (including Hung and myself) filled part of a room with crumpled newspapers and dove into the mess, throwing paper balls over our heads. Some of us tried to read bits of news. Then we tossed the masterpiece into the trash. Hung couldn't stop laughing and said we were all garbage anyway.

She wrote home to her mother about the experience. That letter may have been the first honest message to China that revealed the subversive intent of the American avant-garde.

Traditional spellings of
Chinese names and places
have been used in some
sections of this exhibition
catalogue for clarity;
otherwise, the recent
romanization of Pinyin has
been used throughout.

●

The best moments I have are in mid-air, in the airplane, because I know nobody can reach me, and I am going from one place to the other, so I'm in the middle of nowhere.

Hung Liu, 1997[1]

In 1988, four years after coming to the United States, Hung Liu painted *Resident Alien* (cat. 1), a painting of her green card in which she shows herself bracketed between the two cultures that have shaped her adult life and her art. In a photograph taken that same year she sits in front of this monumental painting (60 x 90 inches), wearing a jumpsuit and tennis shoes, with hands firmly clasped over her crossed legs (fig. 1). Opposite her, bottom left, are her brushes and paint boxes, her artist's tools, through which she claims authorial power over her image. Her self-portrait on the green card, severe and unembellished, is based on a government document, yet becomes quietly assertive and even critically resistant through the large scale it acquires in the painting. Both the painted image and

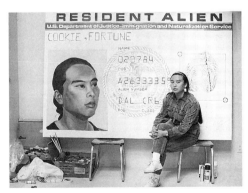

Fig. 1 Hung Liu in front of *Resident Alien*, 1988, at the Capp Street Project, San Francisco, California, July 21, 1988. Photograph: Ben Blackwell, Oakland, California.

the seated artist in the photograph reflect seriousness and self-confidence. The grey jumpsuit she wears, which resembles army fatigues, alludes to the militarism of the Cultural Revolution that so profoundly affected her life as a young adult. In this suit, which she calls her "working clothes," she feels both comfortable and empowered. "It has a military, proletarian, and working class feeling and is even rather macho."[2]

Resident Alien is a parody of many traditional images of official Western and Chinese self-portraits of artists embedded in our memories. The image of the artist in both the painting and photograph also questions Western conceptions of the exotic Orient with geishas and concubines or ladies of aristocratic families in embroidered silk robes. And yet it was precisely these Chinese women that were to form the core of Liu's oeuvre during the next five years. The artist, whose youthful appearance in the 1988 photograph belies her actual age (she had just become forty), had been awarded a residency at the Capp Street Project in San Francisco that same year. Being an artist-in-residence at a prestigious art project in her adoptive country proved to be a turning point in Liu's career. *Resident Alien,* with its large scale and sense of self-assurance, was an expression of this significant moment.

The self-portrait in *Resident Alien* is that of a modern Chinese woman who has lived through and survived the major cultural upheaval that shaped modern China. It is also the image of a woman who made the decision to leave her country in order to live in another country, where she hoped to find more freedom, but where her status as a resident alien would always mark her as an

Other. Liu has been very conscious of the crossing of borders and its impact. She commented recently that "The border is psychological and shifts from one side to another because you can cross a borderline and then you become the Other."[3] Whether she knew it in 1988, she would in the subsequent decade continually move, both physically and metaphorically, between two lands in neither of which she could be her "real self," because that self was and is somewhere in between "in mid-air" where, as she has stated, she has her "best moments," that is, moments of complete freedom from cultural constraints and borders.

"Cookie, Fortune," the name Liu invented for herself for the painting of her green card, is an American cliché about Chinese culture. It is neither Chinese nor American, and yet it somehow identifies a specific group of people in the minds of those who are not Chinese. Liu has falsified other information in her painting: she identifies 1984, the year she immigrated to the United States, as the year of her birth, rather than 1948, the year she was born in China. The reversal of the numbers in the two dates creates an ambiguity: it could be a mistake or an intentional reference to her birth as an independent artist after reaching the States and to the end of the Cultural Revolution. Equally ambiguous is the immense fingerprint in the right-hand side of the painting, which looks much like the imprint of a bound foot and brings to mind the ancient Chinese custom of foot binding, popularized in the Sung Dynasty (A.D. 960-1279). Though originally a sign of class and high rank, foot binding, in fact, rendered

women incapable of free movement and literally bound them to their status in Chinese society. It also had erotic and fetishistic implications and was tied to one of Chinese women's traditional roles as objects for male gratification. The contrast of this gigantic imprint of a finger/bound foot, and the seated artist in her tennis shoes in the 1988 photograph, therefore, acquires an added meaning, especially since the practice of foot binding would become a central subject in Liu's work, beginning in 1989, with *Goddess of Love, Goddess of Liberty* (Dallas Museum of Art, Dallas, Texas) (cat. 2). The powerful image of this frontally seated Chinese woman, exposing her deformed feet, became emblematic in Liu's work and she returned to it four times between 1990 and 1993.

It is tempting to regard *Goddess of Love, Goddess of Liberty* as the complete opposite of *Resident Alien*. Equally monumental (72 x 96 inches), the painting seems to represent everything Liu had left behind, or hoped to leave, when she came to the United States: woman as sex object (as depicted in the traditional scene of the amorous couple on the porcelain vessel next to the seated figure) and woman immobilized and rendered powerless by the deformity imposed on her by culture (in the image of the seated figure). Yet, through her paintings, Liu asserts that she has left none of this behind. On one level she identified with the woman, as she wrote in 1992: "Although I do not have bound feet, the invisible, spiritual burdens fall heavy on me."[4] The image of this woman is as much a part of her story, of the narrative of her life, as is the Cultural Revolution. In fact,

this and the other images of anonymous Chinese women appearing in her work in the early 1990s actually convey a sense of Liu's personal and cultural loss. They are part of a past she had not known about while in China. Believing, as she does, that "it is impossible to abandon your past," Liu in her paintings was putting her past "out there to share with other people."[5]

Goddess of Love, Goddess of Liberty, like *Resident Alien*, is based on a photograph (fig. 2), in this case one given to her by an artist friend. Later she found another photograph of the same woman reproduced in a book entitled *The Face of China*, a collection of images taken by foreign tourists in China between 1860 and 1912, and published in the United States.[6] While in China, Liu could never have seen these or the photographs of young prostitutes that

she has used as sources for many of her paintings since 1991. Such material was destroyed during the Cultural Revolution book burnings and it is rather miraculous that these particular books survived. Liu discovered them in a Beijing film archive during a 1991 visit to China and these images, e.g. *Madonna* (1992) (cat. 6) and *The Raft of the Medusa* (1992) (cat. 7), became a new reality for her, a part of her history. When she first saw the photographs and books in a shabby cardboard box, she "stopped breathing."[7] It was then that she realized that "a lot of true history was either forgotten or hidden." In her paintings the anonymous prostitutes become a metaphor for the loss of identity. These young women "displayed in a photo-studio setting like products in a mail order catalogue" needed "to be heard, to be recognized."[8] Liu surrounded herself with their photographs and looked at them over a substantial period of time, before choosing one to paint. They almost became a family album of ancestors, whom she knew and who provided comfort.[9]

The woman in *Goddess of Love, Goddess of Liberty* most likely was not a prostitute but somebody's wife. The foreign-tourist photographer probably paid a substantial sum to the husband to be allowed to photograph her with exposed feet, for in China to show uncovered bound feet was considered worse than being naked. We will never know the woman's true story or the particular circumstances that led to this stark photograph. Painted immediately after the tragic events at Tiananmen Square, her image also became in the artist's mind an emblem of liberty and courage, expressed in

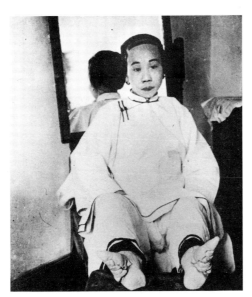

Fig. 2 Photograph of Chinese woman exposing her unbound feet, ca. 1900.

the act of removing her stockings. Painted in black and white and sepia, the seated figure contrasts in every way, in both form and content, with the red pendant panel framing a traditional Chinese image of amorous lovers on a porcelain vessel. The Chinese practice of keeping women's deformed feet covered even during love making is clear in this image, based on a photograph of an antique Chinese bowl, where the nude woman's tiny feet are encased in short silk stockings.[10] The contrasting seated woman, with exposed feet and white clothes, a parallel to classical drapery, also became for Liu a Chinese goddess of liberty.[11] The title of the painting is both serious and ironic, the sad and dignified deformed woman becoming for Liu "almost a holy figure."[12] Goddess of liberty, vessel of love, nameless woman with a story we shall never know: all these contradictory meanings cross in the painting.

In *Virgin/Vessel* (fig. 3), the 1990 version of this image, Liu dispensed with the side panel and placed the image of the amorous couple, again on a vessel and within a brilliant red frame, on the woman's chest, over her heart and most of her vital organs. Here, however, the vessel is a snuff bottle with a lid, suggesting both the availability of the woman for male pleasure (the small snuff bottle held in the man's hands close to his nose to inhale the aroma) and a greater independence in the closed, almost heart-shaped vessel. The hanging broom, a significant three-dimensional object in both paintings, here is shifted to the left and on the right is an ancient Chinese inscription. The large broom has various meanings. For example, since the right side for the character "woman" in Chinese is "broom," the painting implies an

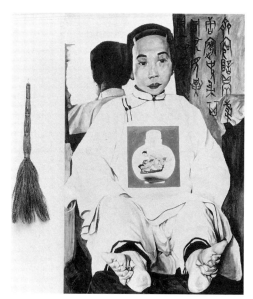

Fig. 3 Hung Liu, *Virgin/Vessel*, 1990
oil on canvas, broom
72 x 48 inches
Collection of Bernice and Harold Steinbaum
Courtesy Steinbaum Krauss Gallery,
New York, New York

equation of the two; and in this context, it also alludes to the homely female task of sweeping floors and, by extension, to the low social position of women in early-twentieth-century China. The inscription, a couplet in Chinese calligraphy on the right, which neither the foreigner nor the contemporary Chinese viewer can read, visually asserts the presence of a long tradition which still influences current actions, like foot binding, but whose original meaning in the distant past has been lost.[13] The few scholars conversant with ancient Chinese calligraphy and poetry would recognize the form of the couplet and its source, for such couplets were placed on each side of doors to celebrate festivals (New Year's) or special

occasions (weddings, grand openings of a new business). By placing both lines of the couplet on one side, Liu creates an imbalance and breaks down the balance of the male (yang) and female (yin) principles that underlies both the form and meaning of the poem. In this case the first line speaks about male guests enjoying themselves at a public social occasion with music and good food and the second about women handling the broom and the dust pan. The couplet then, once its full meaning is understood, reinforces the meaning visually established by the broom. But, even in excavating the full meaning out from under layers of history, the artist is able only to convey it partially and incompletely; the couplet remains a relic of the past unavailable to most viewers. Yet, as the artist has suggested, the painting can acquire new meanings in a contemporary context. The presence of the broom, for example, can be interpreted as "sweeping the truth under the rug," the truth about the deformity and pain of foot binding or, more recently, the truth about the events at Tiananmen Square, where the evidence of daily slaughter and destruction was carefully removed by the Chinese militia.[14] The broom can also be read as a gigantic painter's brush: the brush by means of which the artist is attempting to recapture some of the lost history which can no longer be possessed.

Madame X (fig. 4), the 1993 version of the seated woman, dispenses with all props and acquires a different reality. Her lips are painted a subdued crimson and both her face and feet have a pink tonality. *Madame X*, nameless and without a story, has emerged out of the photograph and has entered a painting where her identity is both asserted

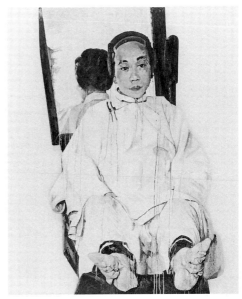

Fig. 4 Hung Liu, *Madame X*, 1993
oil on canvas
80 x 71 inches
Courtesy of Steinbaum Krauss Gallery,
New York, New York

and denied, as the loosely dripping paint erodes the potential solidity of her flesh. The painting again suggests that the truth of her past is forever lost to us and that we "can never truly possess" it, as Trinh T. Minh-ha has suggested in her discussion of the story of women's lives, the story that "never really begins nor ends . . . The story that circulates like a gift; an empty gift which anybody can lay claim to by filling it to taste, yet can never possess."[15]

Perhaps it was precisely the feeling that she could never possess the stories of the anonymous women that prompted Hung Liu in 1993, after having surrounded herself with their photographs for four years, to turn to images of her actual family: her

mother, *Ma* (1993) (cat. 9), her grandmother, *Grandma* (1993), and herself in front of her ancestral cemetery in northeast China, formerly Manchuria, *Burial at Little Golden Village* (1993) (cat. 10). This series concludes with a moving photograph of Liu and her father, whom she rediscovered in 1994, and the painting she made from it, *Father's Day* (1994) (cat. 15). She had not seen her father, who had been a captain in Chiang Kai-shek's Nationalist army, since early childhood. Her mother had been forced to divorce him after the Communists came to power with the promise of safety for her and her child. Liu did not know she had a father until, at 46, she found him in a labor camp near Nanking, from which she arranged for his release in January 1995. She found her father, but the bonds of shared experience had been lost forever: "How could he understand my problems when I was in the Cultural Revolution," she remarked.[16] In *Father's Day,* holding on to her elderly, transparent father, whose body dissolves into washes of paint, Liu emphasizes the similarity of their facial features. But the vigor of her body contrasts with his frailty, echoed in the fragment of antique Chinese carving on the wall. The carving also refers to the ancient tradition both father and daughter came from, but can no longer share in a meaningful way. This is Liu's only melancholy self-portrait.

In trying to re-create her own story, Liu was moving towards autobiography and was, in fact, entering a terrain equally unmapped as the stories of the anonymous nineteenth-century women whose photographs she has so closely studied. As Soshana Felman suggested in 1993, "none of us, as women, has yet precisely, an autobiography . . .

positioned as the Other, estranged to ourselves, we have a story that cannot by definition be self-present to us, a story that in other words is not a story, but must become a story."[17] Felman concludes that as women we "might be able to engender, or access our story only indirectly . . . by reading . . . into the texts of culture, at once our sexual difference and our autobiography as missing." It is this lack, this absence, that Liu is addressing in her paintings. She first saw it in the photographs of the anonymous and story-less women, but even the certainty of her mother's and grandmother's existence could not fill the chasm. In the 1993 painting she showed her mother as a cut-out, in front of but separate from the vast expanse of the Chinese landscape outside Beijing that she had visited as a tourist. *Ma* herself remains unspecific and motionless. Truncated and inactive, she is set in front of a land and a history that is hers but within which she has not found her place.

In search of this history and perhaps looking for more tangible and historically identifiable images, Liu turned to the late Qing Dynasty (A.D.1644-1911), China's last imperial family. The elegantly attired woman in *Cherry Lips* (1995) (cat. 17) was a member of the imperial household. A secondary wife from a noble family, she was the paternal grandmother of the last Emperor. But her story too, beyond the briefest facts, has vanished and in the painting her recessive image is held within the flat surface and is visually less assertive than either *Madame X* or *Ma* or even some of the young prostitutes such as *Madonna* (1992) (cat. 6) or *Mona Lisa II* (1992) (cat. 5). She is as nameless as they are, as the title of the painting indicates.

It should not come as a surprise that in her most recent work Hung Liu has turned to even more anonymous Others in the cities and villages of China: people working, children eating, passersby whom the camera has caught as they perform their daily tasks. Their images help to fill the silences of history by crossing the borders that separate poor and rich, nobility and worker. They provide additional fragments to the stories that "need to be heard and recognized" and are part of Hung Liu's constant struggle to create and discover her identity. As she commented in 1996 in assessing the meaning of her painting *Resident Alien,* "It is not about being an immigrant, it's about a state of transition, the constant struggle about your identity, between the official paperwork and who you really are."[18]

In trying to discover who she really is, Hung Liu continues to look for those whose stories have not been recorded, can never be possessed, and still need to be read into the texts of culture. In doing this she is setting free her creative spirit, which neither the Communist régime nor the Cultural Revolution were able to extinguish at a time when her artistic goals were "simply to paint, or at least to paint something that didn't have Mao's face on it." The freedom and the urge to be creative, usually considered a Western phenomenon, Liu finds rooted in her native Chinese culture as well, in a long tradition that precedes recent political events.

Notes

1 Hung Liu, "Staging Reality: An Interview with Hung Liu," interview by Kathleen McManus Zurko, *Hung Liu: A Ten-Year Survey 1988-1998* (Wooster, Ohio: The College of Wooster Art Museum, 1998), 37.

2 Liu in conversation with the author, October 1997.

3 Hung Liu, "Staging Reality," 40.

4 Allison Arieff, "Cultural Collisions: Identity and History in the Work of Hung Liu," *Woman's Art Journal* 17 (Spring /Summer 1996): 37.

5 Teresa Annas, *The Virginian-Pilot,* 8 November 1995, 1-3(E).

6 Arieff, 36. The full title of the book is *The Face of China As Seen by Photographers and Travelers 1860-1912* (London: Gordon Fraser Gallery, 1978). The photograph in this book shows the woman with her shoes on, her short non-functional legs and tiny feet hanging from the chair in which she sits. Liu used this image in a painting entitled *Golden Lotus /Red Shoe* (1990) (fig. 7), in which she contrasts the older woman with a young female revolutionary dancer, her feet firmly planted on the ground, reaching upwards. See *Hung Liu: The Year of the Dog 1994* (New York: Steinbaum Krauss Gallery, 1994), XIV.

7 Roslyn Bernstein, "Scholar-Artist: Hung Liu," *The Year of the Dog 1994,* VIII. The nineteenth-century book Liu found is entitled *Famous Prostitutes in the Whole Country.* The Chinese prostitutes were dressed in Western clothes and set to appear engaged in Western activities, e.g., rowing a boat or flying an airplane, in order to appeal to Chinese male customers who considered anything Western of superior quality.

8 Jonathan Burton, "Arts Profile," *Asia Times,* 2 August 1996, 11. See also Liu's 1992 "Artist's Statement," Steinbaum Krauss Gallery, New York City.

9 Liu in conversation with the author, October 1997.

10 A Chinese artist would paint female genitalia but never a naked crippled foot. Arieff, 38. Julia Kristeva, *About Chinese Women,* translated by Anita Barrows (New York and London: Marion Boyars, 1986), 82.

11 Hung Liu, "Staging Reality," 43.

12 Liu in conversation with the author, October 1997.

13 In order to find the couplet, Liu had to do research in a book on traditional Chinese couplets, written in an ancient script style, used primarily by scholars.

14 Liu in conversation with the author, October 1997.

15 Trinh T. Minh-ha, *Woman, Native, Other: Writing Postcoloniality and Feminism* (Bloomington: Indiana University, 1989), 1-2.

16 Annas, 1-3(E).

17 Shoshana Felman, *What Does A Woman Want? Reading and Sexual Difference* (Baltimore: Johns Hopkins University Press, 1993), 14.

18 Burton, 11.

●

A WOMAN in a white dress sits against a mirror; her face is composed yet expressionless. How could they do it to her? How could she let it happen? Not only the original mutilation, but the display of that mutilation now, for the camera: in what kind of masculine imagination could the exhibition of those broken and infantilized feet possibly be an erotic provocation, a prelude to the scene of intercourse that decorates the porcelain vessel next to her? Of course, we already know the answer. The practice of foot binding that began at the T'ang court may originally have been conceived in terms of erotic allure, but its more important effect was to immobilize women and confine them. As the *Neuer-Ching* stated, "Feet are bound, not in order to make them beautiful as a curved bow, but to restrain the women when they go outdoors."[1] Though historians, wary of a "victim" thesis, have emphasized the ways in which, despite the weight of the Confucian

family system, women in traditional society were able to acquire and assert some measure of independent power and influence, that qualified view is not the one Hung Liu's image presents: the figure's status as victim is uppermost. Women's status in traditional society can be summed up through the ideogram for *wife* that Hung Liu quotes: a combination of *woman* and *broom.*

Yet the meanings set in motion by Hung Liu's *Goddess of Love, Goddess of Liberty* (1990) (fig. 5 and cat. 2) go beyond the shock and indignation that the image of bound feet inevitably releases. While never losing touch with that anger, *Goddess* also traces the network of discourses in which such imagery has circulated in the past and the present, and in widely differing cultural contexts. The maker of *Resident Alien* (1988) (fig. 6 and cat. 1) is intensely aware of the particular destiny that lies in wait for persons and images that represent "China" in the West. *Goddess* is a historical painting not only in the sense that it excavates the brutal treatment of women in pre-Revolutionary China, but in its movement beyond that site to other, later discourses that move in on the image to claim it for their own.

As an image of China-for-the-West, *Goddess* closely follows the pre-established discursive patterns of its Western setting and reception. All the formulations of orientalist discourse are present. First, the mapping of the relation between the West and China in terms of a gendered hierarchy: "China" is a woman. In the words of the Chinese protagonist of David Henry Hwang's play, *M. Butterfly* (1988), "The West thinks of itself as masculine—big guns, big industry, big money—so the East is feminine—weak,

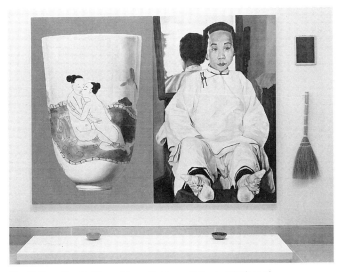

Fig. 5 Hung Liu, *Goddess of Love, Goddess of Liberty,* 1989 (cat. 2)
oil on canvas, mixed media
72 x 96 inches
Dallas Museum of Art, Dallas, Texas
Museum League Purchase Fund 1990.91

delicate, poor—but good at art, and full of inscrutable wisdom—the feminine mystique."[2] Second, the relation "China stands to the West as feminine to masculine" is reworked in terms of the gaze. If the West is the subject of vision—if the West is to *maintain* its place as the subject of vision—then "China" must be positioned as the object of knowledge, as spectacle before that gaze: "China" is an image, a painting. Third, the image is placed in an implied temporal horizon where the West is assumed to have mastery of progressive time, and the non-West accordingly represents the archaic—time stagnant or standing still, frozen "immemorially" in customs unchanged since the T'ang. Lastly, the orientalist gaze finds in the image of bound feet a sexual interest with a dual basis in fascination and in repudiation. On the one hand, "China" signifies the zone of perversions: in quick succession, fetishism, sado-masochism, concubinage, and a mysterious oriental *ars erotica* (the porcelain cup). Writing in this vein in *Des chinoises*, Julia Kristeva speaks of "these Chinese women whose ancestresses know the secrets of the bedchamber better than anyone,"[3] of "an economy based on the *jouissance* of the woman without sacrificing that of the man."[4] On the other hand, the fascinations of this exotic sexual economy are rejected as despotic and alien: in this now repudiating perspective, "China" is backward because it lacks the West's historical experience of conjugality, companionate marriage, and the political emancipation of women.

It is at this point that orientalist discourse interestingly intersects with the discourse of

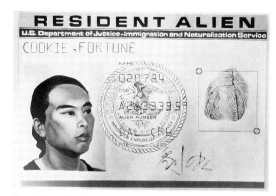

Fig. 6 Hung Liu, *Resident Alien,* 1988 (cat. 1)
oil on canvas
60 x 90 inches
Courtesy Steinbaum Krauss Gallery,
New York, New York

Americanization whose clearest expression is Hung Liu's *Resident Alien.* The society of the United States, we know, has many voices, many ethnic groups. Heritage is remembered and honored. But what is especially required of the holder of the green card is the presentation of a cultural identity that is now surpassed and overcome: "Where are you from *originally?*" You are here, now. Which means that the old country must be seen as *very* old, its most antiquated and senescent forms are henceforth the very ones through which it is to be principally remembered. The discourse of the green card absorbs into itself and perpetuates in another key all the formulations of an orientalism which, in the same breath, it claims to have outgrown: yes, things in the old country were bad— *remember them!* Meaning: publicly declare your severance from them, if you are to become one of *us.*

Yet Western discourses, of orientalism and immigration, are not the only ones that

circulate around the imagery of old China. Throughout the twentieth century the attack on the Confucian family system has been one of the most powerful and enduring means of establishing the terms of the new China. Mao's early letter on the suicide of Miss Chao, who chose death rather than submit to the marriage her parents had arranged for her, spoke of her as imprisoned in "three iron nets"—her own family, the family of her in-laws, and Chinese society: "once caught in these three nets, it was in vain that she sought life in every way possible."[5] To the progressive, enlightened writers of the May Fourth movement, smashing the oppressive structures of the traditional family was essential if China was ever to organize itself as a new nation. In 1924 the banners in Beijing read "Same Pay for Equal Work," "Monogamy to Prevail," "Absolute Freedom of Marriage and Divorce," "Abolition of Prostitution."[6] Ba Jin declared that his purpose in writing his attack on the traditional family, *Jia* (*The Family*, 1930), was to "cry out my own *J'accuse* before a dying system."[7] Equalizing the power relation between men and women became a central aim not only of May Fourth intellectuals but of the Party itself. The provisional constitution adopted at the First Congress of the Chinese Republic in 1931 declared that:

> *It is the purpose of the Soviet Government of China to guarantee the thorough emancipation of women; it recognizes freedom of marriage and will put into operation various measures for the protection of women, to enable women gradually to attain the material basis required for their emancipation from the bondage of domestic work, and to give them the possibility of participating in the social, economic, political and cultural life of the entire society.[8]*

Such efforts were intensified in the early 1950s, which saw the passing of legislation intended to destroy, once and for all, the feudal remnants of the old marriage system (including patrilocality).[9] For the generations born after 1949, such practices as foot binding and bride price represented everything that the new China had succeeded in abolishing.

The figure of the foot bound woman in *Goddess* exactly matches the triumphalist tone of new China rhetoric, not only because feudal arrangements between the sexes had been officially eradicated, but because the public demonstration of the horrors and infamies of the old régime had come to play such a crucial role in the Party's efforts to galvanize the country. "Speaking bitterness" *(su ku)* narratives acted as a powerful discursive apparatus evoking the appalling conditions of the "old" society and demonstrating the clear benefits of the "new," socialist present. In her analysis of "speaking bitterness" narratives during the Cultural Revolution, Ann Anagnost attributes their effectiveness to the way in which "the speaker comes to recognize himself as a victim of an immoral system rather than suffering as a result of bad fate or personal shortcoming."[10] The main objective of "speaking bitterness" is to spell out the brutal facts of class exploitation, to transform personal suffering into wider, class-based suffering, and to place that historical pain in the past tense, with a dramatic break

between "before" and "after" the revolutionary intervention of the Party.

Here it is important to remember Mao's own conception of class, and its specific departures from the Soviet model. In the Leninist perspective, class consciousness arises directly out of the overall relationship to the means of production. In industrial societies, therefore, social consciousness necessarily remains alienated until workers come into ownership of the society's productive base. Mao determined that such an analysis was inadequate for China's predominantly agrarian society: industrial development had not yet reached a sufficient level for alienation to be attributed to the relation to the means of industrial production. Accordingly the subject of class, in Mao, is defined differently, in terms of powerlessness and naked exploitation. "Speaking bitterness," which exposed the brute facts of class domination (and cast it into the past tense) corresponded to Mao's formulation of the essential revolutionary moment. Hence the centrality of brutality and domination in so many products of the Cultural Revolution. In *The Girl with White Hair,* by the Xi'an Ballet, a young peasant girl is persecuted by the local lord and tortured by the lord's Confucian mother, before finding revolutionary comrades who can help her. In *The Store that is Headed for the Sun,* a young girl breaks with her family, is slandered by anonymous letters, reduced to poverty, abandoned by her lover—until the local secretary of the Party steps in to save her.[11] As Anagnost points out, "speaking bitterness" was by no means confined to the stage: encouraging individuals to recall the horrors of the old

régime, and compiling such records in the Party's archive, became crucial ways of gathering grass-roots support, and of redefining local history.

Placed in the context of new China, *Goddess* reveals discursive networks significantly different from those in the West. The woman in Hung Liu's image is claimed not only by orientalist or assimilationist ("green card") frameworks, but by narrative forms that seek to establish the terms of Chinese modernity by focussing reformist consciousness on the barbarism of the Confucian family system, using "speaking bitterness" as revolutionary praxis. If we consider Hung Liu as a bi-cultural artist—that is, if we take into account the context of the People's Republic of China and not only the United States—what emerges is the power of a whole series of discourses, Chinese and Western, to move in on the work's central image and to mark it as their own. Hung Liu sets up an image that is destined from the first to be appropriated by discursive régimes on both sides. What, then, of her own stance toward the figure she has painted?

In summoning out of the archive an image that can be so vigorously claimed by very different discourses, each of them backed by powerful geo-political investments, *Goddess* underscores the extent to which discourses of victimization, of whatever origin, can tend to silence the victim by speaking in her own name. The figure of the woman who is the subject of the image is caught in at least three rhetorical "iron nets": old China *(wife = woman + broom),* new China (smashing feudalism, speaking bitterness), and the West (orientalism, a certain multiculturalism).[12] In such

circumstances the voice and presence of the woman herself are overlaid and lost in the struggle over the "rights" to her suffering. Hence the deeper, memorializing aspect of Hung Liu's work, which has little of Walter Benjamin's faith in the power of the photograph to reveal actual social conditions. Rather, the photograph is a surface that is mute, or ventriloquized by the various narratives that speak in its name. In Hung Liu's work the status of the photograph is closer to than of Kracauer than to Benjamin:

> *Once a photograph ages, the immediate reference to the original is no longer possible. The body of the deceased person appears smaller than the living figure. . . The old photograph has been emptied of the life whose physical presence overlay its merely spatial configuration. . . The truth content of the photograph is left behind in its history; the photograph captures only the residuum that history has discharged.*[13]

Kracauer's remarks precisely describe the conditions surrounding the photographs appropriated in Hung Liu's work. As the figures in historical photographs age, moving away from the original context in which they would have been instantly and intimately recognized by contemporaries, they inevitably lose whatever capacities they may once have had possessed to speak in their own voice. The woman in *Goddess* is spoken, and spoken for, many times over.

The link between the painter and the woman in the photograph is, accordingly, a historically impossible relation: impossible,

because there is no way for the artist's own feelings, of sympathy or rage, to reach the figure; and impossible because the indignation or anger that the work releases have already been co-opted as elements within powerful, pre-existent discourses, moving these emotions also into the realm of "being spoken" rather than "speaking." The emotional power of the image lies not only in what it shows of itself, but in the uses to which imagery of "old China" has been subjected by subsequent history. The woman with bound feet is absorbed and contained within discourses that already instrumentalize her suffering. Western discourses of orientalism and assimilation, as well as the anti-Confucian discourses of the new China, all take indignation as their affective basis—which at once raises the problem of how the strong affect provoked by the photographed image may conceivably be extricated from the various "iron nets" that have already captured and manipulated the image's emotional charge. This, in turn, realigns the persona of the painter with the photographed figure, in a realization of their *parallel* voicelessness or mutism.

Hung Liu's use of historical photography can be understood as a strategy which, by emphasizing the prior or anterior existence of the photograph, recognizes and dramatizes the limitations that restrict the artist's discursive agency in situations where victimization has already been exploited by groups in power. Though the artist has powers of selection, combination, and embellishment, essentially the act of translating the photograph into the language of painting renounces the terms of creativity with which the art of painting has been associated in the West. Setting aside

painting's injunction to create images never before seen in the world, the work of the painting is to bring into tentative alignment the artist and the figure, in their dual positions of discursive disempowerment. Where the discourses of the West and of new China move in on the photographed figure from the outside in order to claim her as evidence of their own truth-claims, the act of recreating the photograph in terms of painting wards off at least some of the expropriating force which those discourses possess. The work of the brush is to *suspend* that alienating force-field, to keep it at bay for long enough that a different, non-expropriative dynamic may come into play. The relation of painting to photography in Hung Liu can perhaps be understood as a means of introjecting the figure, and specifically, the figure's suffering. In each of the "external" discourses, that suffering is recognized, yet immediately disavowed, as a form of pain that "we" (in the West, in the People's Republic of China) no longer know. The reworking of the photograph in terms of painting proposes a placing of the other's suffering *inside* the self. In the emotional register of *Goddess,* this has everything to do with the mother-daughter bond.

The crucial task of the brush is to revise the photograph in such a way as to rebuild the possibility of a mother-daughter bond that is also recognized as having been radically broken by history. Broken, first and foremost, by the events of the Revolution, which not only swept away much of the historical evidence concerning women in pre-Communist China (making it necessary for Hung Liu to excavate a lost history of women), but which posited an absolute

generational break between the women of the past and those of the present. This is surely one of the senses of the broom that appears in *Goddess:* that the old Confucian thinking, in which women were thought of as domestic chattels, has now been swept away by the Revolution's own success. The woman in *Goddess* belongs to a deposed order which enlightened thought has thoroughly cleansed and purified. That being the case, what possible value could there be in *identifying* with the impure past? How could such identification be anything but counter-revolutionary?

From the first, the Party leadership viewed with suspicion China's incipient feminist movements for concentrating on "the emancipation of women as a sex from the oppression of men," failing to see that "the low position of Chinese women was due to a backward social system, and that the emancipation of women can only come with a change in the social structure, which freed men and women alike" (Ts'ai Ch'ang, 1937).[14] That position, already firmly entrenched by the 1930s (if not earlier) was strongly reaffirmed in the years leading up to the Cultural Revolution. In an article entitled "How To Look at the Women Question" that appeared in the Party's theoretical journal *Red Flag* in 1964, abstracting "women's problems" in a way that transcended the terms of class analysis was declared to be a "bourgeois viewpoint."[15] In the Party's fundamental social analysis, women simply did not qualify as a class; there could, therefore, be no basis for connection or solidarity between women of the past and the present, or between grandmothers, mothers, and daughters. In the imaginary of

the Cultural Revolution, true daughters of the Revolution have no need of their parents of either sex, but only of a political or symbolic father (the Party, the Chairman).

In *Golden Lotus/Red Shoe* (1990) (fig. 7), Hung Liu stages an imaginary confrontation between a woman, who might well be the protagonist of *Goddess,* and one such daughter of the Revolution. The image makes clear why, in the case of modern China, the idea of a historical continuum between women of successive generations is so difficult to establish.[16] Though the dictates of the Party during the Cultural Revolution are often remembered in post-Mao history as having been imposed from the outside, and as hollow and coercive, what the juxtaposition

in Hung Liu's image captures is the mechanism of their internalization. Mao's poem on the splendor of the Women's Militia spelled out a revolutionary ideal that gave women unprecedented powers centrally including the right to bear arms:

> *Proud and alert, they carry five-foot guns,*
>
> *The first rays of the morning sun illuminate the drill-field.*
>
> *The daughters of China are filled with high resolve,*
>
> *To red garments they prefer the uniform.*[17]

In the tautness and resolve of Hung Liu's figure from the Women's Militia, one sees how persuasively the rhetoric of female military prowess may have acted on the subjectivity of the Party's women followers: it provided an unarguable route of escape from the conditions of servitude represented by their "feudal" counterpart on the image's right. As with the rhetoric of "speaking bitterness," the discursive apparatus utilized by the Party was effective precisely because it operated from the inside, inciting into being a subject where none existed before. In the words of Teresa de Lauretis: "Subjectivity is engaged in the cogs of narrative and indeed constituted in the relation of narrative, meaning, and desire; so that the very work of narrativity is the engagement of the subject in certain positionalities of meaning."[18] By internalizing the ideal, daughters of the Cultural Revolution may have acquired some of the powers of their symbolic father, the Party, yet this increase in their capacity also entailed that, when narrating their own

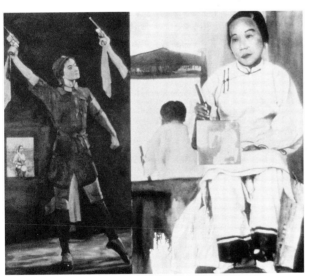

Fig. 7 Hung Liu, *Golden Lotus/Red Shoe,* 1990
oil on canvas, silkscreen on silk
48 x 56 inches (diptych)
Collection of Domna and Frank Stanton
Courtesy Steinbaum Krauss Gallery, New York, New York

reformulated life-history before others or for themselves, in their self-remembering they need no longer discover their mothers at any point; like Athene, the daughter whom Zeus appointed as guardian of his thunderbolt, they spring forth directly from their father's mind. On the right side of *Golden Lotus/Red Shoe,* the woman embodies the full, mutilating force of sexual difference. On the left of the image, sexual difference is presented as neutralized, or surpassed. The subject of the Party may happen to be female, yet it is as if that fact is now incidental or irrelevant: the revolutionary daughter need no longer be concerned with family or personal relationships, or with "women's issues" (desire, marriage, motherhood). Revolutionary sublimation is intense and purifying; part of its allure is exactly that it frees the daughter from the burden of ambivalence toward the mother that might otherwise complicate, and possibly undermine, the clarity of the revolutionary project.

In *Goddess,* the reworking of the photograph by the brush stands in opposition to the official ex-inscription of the mother-daughter relation that the culture of the Party sought to impose on its followers. In *Goddess* each stroke on the surface of the canvas acts as an incremental restoration of that historically disavowed relation, creating an imaginary continuum in which the historical suffering of women may be recognized and honored. If many of Hung Liu's early paintings involve frames that curve or arch, this is not only because that was a preferred format in early twentieth-century photography, but in order that the original curve of the sepia print may become shrine-like, a space of reverence and

commemoration. To that extent, Hung Liu's brushwork is intensely personal, involving, as it does, a ceremony of introjection in which the one, exiled daughter is the only survivor able to remember her family's past. And yet it is brushwork that does not seem to be especially concerned with establishing a unique, personal signature. Many viewers surely recognize in Hung Liu's hand an institutional formation, a training: the application of paint on canvas is inseparable from the idea of the academy, and specifically that of the academy under Socialist Realism. Where Hung Liu perhaps comes closest to being a latter-day scholar-painter is in the way her hand of itself writes its own place in the history of representation. Just as the style of the Chinese academy portrays its own genealogical roots in Western nineteenth-century painting, transmitted first to Shanghai and then reformed after 1949, Hung Liu's hand writes a story of a first formation, in Beijing, then a second formation, in the United States, and then a third, in the constantly changing basis of the stroke's relation to the photograph.

At times, the stroke follows the detail of the photograph with the utmost fidelity: the attention paid to the folds of flesh in the mutilated feet of *Goddess* is meticulous— and, as a result, almost unbearable to view (fig. 8). Here the force of the *detail* comes into its own. If it was precisely the detail of women's lives that was swept away by a modernity that had eyes only for the higher abstractions (the new China, progress, reform), the insistence on the detail is a mode of solidarity with the specific terms of existence and consciousness of the women whose lives were silenced by history. At

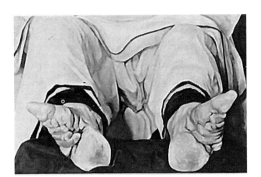

Fig. 8 Detail: *Goddess of Love, Goddess of Liberty, 1989* (cat. 2)

other times, the stroke departs from the photograph, letting thinned paint drip down the surface and corrode it, as though the act of commemoration or introjection were too difficult, perhaps too painful, to be completed.

Theresa Hak Kyung Cha has written: "Let the one who is diseuse [female storyteller], one who is mother who waits nine days and nights be found. Restore memory. Let the one who is diseuse, one who is daughter restore spring with her each appearance from beneath the earth."[19] In *Goddess,* Hung Liu shows how difficult it is for the mother to be found, how essential memory is, and also how broken; and how, when the one who is diseuse is daughter, her words are necessarily faltering and intermittent. There has been too much bad history for speech to be direct.

Notes

1 Quoted in Olga Lang, *Chinese Family and Society* (New Haven: Yale University Press, 1946), 46.

2 David Henry Hwang, *M. Butterfly, with an Afterword by the Playwright* (New York: New American Library, 1989), 98.

3 Julia Kristeva, *Des Chinoises* (Paris: Editions des Femmes, 1974); *About Chinese Women,* translated by Anita Barrows (New York and London: Marion Boyars, 1986), 198.

4 Kristeva, *About Chinese Women,* 63.

5 "Miss Chao's Suicide," originally published in the Changsha *Ta-kung-pao,* 16 November, 1919; translation in Stuart R. Schram, *The Political Thought of Mao Tse-Tung* (New York: Frederick A. Praeger, 1969), 334-337. See also Roxane Witke, "Mao Tse-Tung, Women, and Suicide in the May Fourth Era," *China Quarterly,* no. 31 (1967): 128-147.

6 Elisabeth Croll, *Feminism and Socialism in China* (London: Routledge and Kegan Paul, 1978), 99.

7 Ba Jin, preface to the tenth printing of *Jia* in 1937; quoted in Rey Chow, *Women and Chinese Modernity* (Minnesota: Minnesota University Press, 1992), 97.

8 Conrad Brandt, Benjamin Schwartz and John K. Fairbank, eds., *A Documentary History of Chinese Communism* (New York: Atheneum, 1966), 223.

9 On the checkered history of the implementation of the 1950 Marriage Law and the 1953 Marriage Law Campaign, see Kay Ann Johnson, *Women, the Family, and Peasant Revolution in China* (Chicago and London: University of Chicago Press, 1983), 93-153.

10 Ann Anagnost, "Who is Speaking Here? Discursive Boundaries and Representation in Post-Mao China," in *Boundaries in China,* edited by John Hay (London: Reaktion Books, 1994), 263.

11 On the representation of women during the Cultural Revolution, see Julia Kristeva, *About Chinese Women,* 153-154.

12 Here it is important not to condemn all of multiculturalism as a disguised form of assimilationism; Hung Liu's own work demonstrates how much potential the idea of a radically multicultural society possesses for productive social criticism.

13 Siegfried Kracauer, "Die Photographie," *Frankfurter Zeitung,* 28 October 1927; "Photography," translated by Thomas Y. Levin, *Critical Inquiry* 19 (Spring 1993): 429.

14 Johnson, 43.

15 Ibid., 180.

16 See, for instance, Trinh T. Minh-ha, *Woman, Native, Other: Writing Postcoloniality and Feminism* (Bloomington: Indiana University Press, 1989), 122: "Tell me and let me tell my hearers what I have heard from you who heard it from your mother and your grandmother, so that what is said may be guarded and unfailingly transmitted to the women of tomorrow, who will be our children and the children of our children."

17 Mao, February 1961; Schram, 339.

18 Teresa de Lauretis, *Alice Doesn't: Feminism, Semiotics, Cinema* (Bloomington: Indiana University Press, 1984), 106; cited in Anagnost, 261.

19 Theresa Hak Kyung Cha, *Dictée* (New York: Tanam Press, 1982), 133.

●

It used to be that styles and objects traveled, while artists stayed at home; or if they traveled, they soon came home again, bringing exotic manners with them to dazzle the locals. These artists, then, were assumed to be creatures of their *volk* or class, bound by the conduct and conventions of their own cultural location and social station. Thus, even though they might import, appropriate and employ the manners and materials of other cultures (the way sorority girls trade party clothes) it was presumed that they could only adapt these alien modalities to the *habitus* of their "home" culture, as Picasso supposedly adapted the manner of west African sculpture to the conventions of modernist Europe. In this way, the presumed stability of the artist, within his or her culture, was used to validate the power and validity of "culture" itself as an informing concept.

The moment artists begin traveling and not coming home, however—the moment they begin moving from "culture" to "culture," as Hung Liu and many of her contemporaries have done, the classical idea of "culture" as proposed in nineteenth-century Germany, begins to dissolve, since, in all of its visible attributes, artists *make* culture. Cultures, however, may no longer be said to *make* artists. Thus, to anyone who looks, it should be obvious that Hung Liu (an American artist of Chinese descent—who makes "Western" paintings of "Chinese" photographs—who was educated in China in a European tradition—who has struggled to re-acquire her Chinese cultural inheritance while living and working in the western United States) may indeed be engaged in "cultural production," but the works she

makes are *not* "the products of a culture." They are the products of Hung Liu, and only available to us because the methods, manners, and materials that artists have passed from culture to culture for hundreds of generations have achieved enough transcultural viability to validate her local resolutions of their multivalent possibilities.

I would argue, then, that Hung Liu's paintings do not derive their authority from "culture," but from the transcultural appeal of *paintings* and the manners of painting she employs. Thus, the interest and attraction of Hung Liu's paintings and the pleasure that we take in them today—in the wrecking-yard of history and on the precipice of the millennium—discredits one of the most pervasive fantasies in late twentieth-century art: that "painting is dead." The truth would seem to be that painting is not "dead" simply because *paintings* indubitably are (dead, that is)—because paintings are inanimate, inarticulate, portable *things* of considerable longevity, whose semiotics are invariably iconic and bound by their context. So, even though we can and do "read" paintings, we read them rather as we do the weather and rarely read them in the same way for very long. In other words, paintings are utterances, but they are not language, and they are not *texts,* since the defining characteristic of linguistic texts is that, even though their *meanings* may change depending on their context, the *way* we read them, does not.

In a text, we can easily distinguish "noise" from "information." In a painting, one day's "noise" is the next day's "information." The "signifying attribute" is never stable, so the

first question with a painting is never what it means, but which of its attributes are meaningful, how they become meaningful, and in what order. In a painting, the brushstroke may function as the primary signifier for one set of beholders, the image might for the next, the scale for the next, the color for the next. This is, and always has been, a matter of local fashion, and, as a consequence, paintings are physically incapable of *retaining* the emotional, ethical and institutional meanings that we attribute to them. Such meanings may be assigned to paintings, and we may find them there from time to time, but they do not *inhere* in them.

Thomas Crow may remark that painting in New York, in the 1980s, was "a shorthand code for an entire edifice of institutional domination exerted through the collectors' marketplace and the modern museum," and he may be right (although I do not think he is). This, however, does not mean that Crow's "shorthand code" will still be intelligible in the 1990s, during which period the same painting may just as easily come to function as a "shorthand code" for the haptic, tactile, fractal modes of information that are lost to us in the digitization of post-industrial culture. Because, in paintings, as opposed to texts, the signifier is not absent. It is a matter of choice and deliberation; it is contingent, protean, and irrevocably multivalent.

The attraction of painting as a practice, then, has never been its precision of expression, but the fact that it has meant so much for so long, in so many ways and so many places. As Chuck Close puts it, "You tie some animal hairs to a stick, dip it in colored mud and rub that mud on a surface." Human beings around the world have been doing this for a very long time, and there is every reason for them to keep doing it, simply because the act of painting, due to its ubiquity, calls up a *world* of meaning out of which one can carve one's own—in which the beholder may find their own, as well. So, it well may be that painting, far from being dead, is only now coming into its own as a vehicle of idiosyncratic expression in the practice of artists like Hung Liu.

Consider it this way: For thousands of years, in western and eastern cultures, painting was practiced within the domain of the church, the state, and the academy and subject to their authority. For the last hundred and fifty years in the West, paintings made outside these institutions have concerned themselves with the mechanics of practice and the logic of their history. Since painting today is no longer so concerned or so regulated, it may well be that we are only now beginning to see the practice employed to achieve local solutions that may be said to have cosmopolitan consequences because we are no longer parsing the cultural norms purportedly embodied in artist's practices. We are, however, appreciating the ways in which various artists exploit the transcultural norms of various practices to their own ends.

Now consider how Hung Liu's situation as an artist exemplifies this change: She is an American artist of Chinese descent who was educated in China in a European tradition, that of mid-twentieth century "socialist realism"—a style of heroic painting practiced in China and the Soviet Union and grounded in French academic practice from Poussin to

David—with Chinese socialist realism tending more toward the "classical" Poussiniste manner and Russian socialist realism tending toward the gaudy heroism of David's late "Napoleonic" style. To further complicate this situation, both socialist realism and French academic painting have traditionally opposed themselves in different ways to "mandarin" painterly styles that have both eastern and western manifestations.

As a consequence, Hung Liu's efforts in the United States to familiarize herself with her own Chinese cultural heritage—with the history of Chinese painting and the manner of improvisational, painterly masters like Wang P'o-mo—simultaneously introduced her to the painterly tradition in Western culture that stretches from Titian to De Kooning with its own shifting atmospheres of signification. Not surprisingly, this introduction to Western painterly practice would prove as valuable to Hung Liu's cultural reorientation as her rediscovery of Chinese gestural painting, since it not only provided a cultural bridge, it provided her with a counterweight to the first artistic academy she would confront in the United States—another Poussiniste establishment at the University of California, San Diego. This American "post-minimalist" academy, whose provenance flows from Poussin through David, Puvis de Chavannes, Cézanne and Duchamp, privileged a "conceptual" art rather than the "ideological" art espoused by the Russian and the Chinese academies. Over the years, however, this distinction would become as faint as it actually is.

In fact, in the 1970s, the paintings made by the "photo-realist" wing of this academy differed only in minor details and purported intention from the socialist realism in which Hung Liu was trained. Upon arriving in this country, she would exploit the similarity of these painting styles to theatricalize her own peculiar vantage point. To do so, she would exploit the differing status of photographic subject-matter in China and the United States. The peculiar power of photo-realism in the United States, of course, was grounded in the fact that photographs are both indigenous and ubiquitous in America. Thus, photo-realist painters sought to redeem this quotidian banality by translating photos into art. Hung Liu's photo-socialist-realism, however, was informed by the fact that photographs in China were both rare and exotic, yet provided her only visual access to her homeland.

Responding to these local realities, Hung Liu adapted the formalizing strategies of American photo-realism to the more urgent task of humanizing the formality of the Chinese photographs, opening a door to her own past and culture. Thus, in her first body of American work, Hung Liu paints photographs of contemporary China and *uses* the photograph to distance her manner from the Marxist ideology that informed it in China. At the same time, she works to "open up" the sealed surface of the photograph, that in the twentieth century has transformed our historical memory into a strobed sequence of stop-action "moments." She tries to re-establish that "middle distance" in which the domain of the image and the domain of the artist/beholder intersect—to re-establish that connection and replace the remote instantantaneity of photography with the loose, interactive temporality of the

"studio time" whose memory is embodied in the finished painting.

In Hung Liu's paintings, then, the issue is less about making than matching, of establishing some local intersection, some sympathetic resonance between the actions of the artist, the manner of the painting, and the nature of the subject matter. Thus, her paintings of Chinese imperial life are rendered in a Western "mandarin" style of drips and painterly gestures, establishing that bond, and allowing the rhetoric of mourning and mutability that are associated with those "western drips" to speak of the lost reality of the imperial court. Likewise, when Hung Liu deals with the quotidian subject matter of snap-shots, her work segues into a more demotic painterly style that, for Western beholders, evokes both the nineteenth-century "ink wash" and the anti-heroic mode of "painterly pop" in the American 1950s—most closely associated with the work of Larry Rivers, early Warhol, Rosenquist, and Wesselmann.

Hung Liu finds what fits, in other words, and this procedure of finding what fits, of achieving local accommodations within the global array of artistic practices, emphasizes an aspect of representation that is rigorously suppressed as long as we regard the artist as co-extensive with the culture within which he or she supposedly operates. The fact is that representation is *always* multivalent: it represents both the objects portrayed and the artist who brings the work into being. Subsequent to that, the work represents the beholders who choose to invest it with public value. If, after a suitable period of time, a representation can be said to represent a substantial segment of those who behold it, it may perhaps be said to represent "the culture," as Vermeer and Rembrandt are said to represent theirs.

This, however, presumes that the idea of "culture" will remain a viable one in the fluid global tumult that human beings have created for themselves in this century, and it may well not. It may be that Hung Liu's transcultural, local solutions, to her particular desires in her particular social and geographical situation, constitute a new artistic model which is, in fact, as old as America's transcultural polity of immigrants. This is a model of artistic practice in which works of art represent that which they portray and beyond that, represent not the culture but the loose, diverse society of individuals who hold these works in esteem and invest them with social value. In Hung Liu's case, I count myself a member of this cosmopolitan society.

●

*Once Chuang Chou dreamt he was a butterfly, a butterfly
flitting and fluttering around, happy with himself and
doing as he pleased. He didn't know he was Chuang
Chou. Suddenly he woke up and there he was, solid and
unmistakable Chuang Chou. But he didn't know if he was
Chuang Chou who had dreamt he was a butterfly, or a
butterfly dreaming he was Chuang Chou. Between
Chuang Chou and a butterfly there must be some
distinction! This is called the Transformation of Things.*[1]

On May 23, 1997, on a clear, sunny day, Hung Liu pulled around the
oval at Mills College, Oakland, California, to pick me up for our
interview. Over the course of the next two days, this energetic artist
shared many details about her life and her work. Regularly interrupted
by the overwhelming sound of the BART (Bay Area Rapid Transit)
which roars past her studio in downtown Oakland, we still managed to
discuss a wide range of issues surrounding Liu's life and work. The
quote above, sent to me by the artist after our interview, comes from
the writings of Chuang Tzu, a fourth-century B.C. Chinese scholar who
wrote one of the definitive texts of Taoism. This quote suggests for
Liu not only the fragility of reality, but also, according to the artist, the
"ephemeral nature of the art-making process and the experience of
consciousness as it slips back and forth between my own self-
awareness and how I identify with my subject."[2]

kmz What was it like for you to come of age during the Cultural
Revolution?

hl Well, the Cultural Revolution's full name is the Great Proletariat
Cultural Revolution. It probably gives people the idea that the purpose
was to take over all the intellectual fields by proletarian ideology. It
started in 1966 when I was eighteen. I assumed, like my colleagues,
that it was probably going to be like previous revolutionary
movements where some enemies were criticized and punished, but
life would come back to normal, meaning that we would take the civil
exam and go to college. But the revolution just got bigger and bigger.

The Red Guards began to enter private households and turn them
upside down to find any evidence of counter revolutionary, western,
or feudal values. It started in what we called Red August, and the
Red Guards were encouraged to basically go wild in order to destroy
the Old World. Finally at the end of 1968, after more than two years,

Chairman Mao had a new idea: a whole generation of educated young people would need to be re-educated by the ruling classes— the workers, the poor and lower middle-class peasants, and the soldiers. I was sent to the countryside with millions of my peers.

One day during Red August I remember passing by a Muslim mosque near where I lived. The mosque was being destroyed by the Red Guards. Oddly, the next morning I listened to a news broadcast claiming foreigners had spread rumors and lies against the government, and that the mosque was not really destroyed. This was the first time my whole belief system was shaken because I was supposed to believe, heart and soul, in order, communism, and socialism.

kmz That was the first time you doubted what you were being told?

hl I saw it myself, witnessed one thing, but the broadcast claimed another. I was in complete shock, but I didn't dare question it. How could they lie? Then I questioned my own loyalty. I was scared because this was a life and death thing. Later, this incident reinforced for me how historical photographs could be altered. Like when a few people were actually kicked out of the Party and how they were erased from historical photographs. That scared me because you can literally rewrite history.

kmz Did you own a camera at this time?

hl When I lived in the countryside, I had an old German 120 camera that I kept for a friend. Then I thought maybe I could do something with it for the peasants for fun, and I saw that they had very few photographs except for their identification cards.

So first I started with a few good friends, and then everybody asked if I could take a picture of their families, and I had this great satisfaction and pleasure that I could do something so casual so they didn't have to go to town and to the effort of putting on new clothes. They could just stand in front of the fence or whatever. I went back to Beijing and I bought an enlarger and chemicals from a second-hand store and started to develop the photographs. I didn't have a dark room so I would wait until 9:00 or 10:00 at night when it was dark enough.

kmz After you spent some time in the country, you went back to Beijing to attend school. What was contemporary art like in the late 1970s in China?

hl Closed and pretty tight. If you looked through a catalogue of a show, there could be twenty works by twenty artists that looked like they were done by one person because the style and subject matter were the same: about the revolution or Chairman Mao.

kmz What made you decide to apply to the Mural Program at the Central Academy of Fine Arts in Beijing?

hl That program wasn't too heavy-handed. I could either retreat to ancient traditions or try for commissions for new public spaces. In 1979, the year I entered graduate school, the Central Academy of Fine Arts had a new program called the Mural Program, and I was one of two mural graduate students. This program was started because the government began to do international business and the new Beijing airport was built and they needed artists to design some decorative murals. So they invited well-known, mature artists in their late forties or fifties to participate. One of them was Yuan Yunsheng who did the *Water Festival*.

When I entered school these artists were my teachers. *Water Festival* showed people of Dai nationality from the south, next to Burma. The people were in very sheer dress because the weather was warm there all year. Anyway, there is a very famous water festival held there every spring, and people pour buckets of water on each other. The more water you get poured on you, it means people love you the most.

Yuan took this festival as his subject matter, and I think he visited the Dunhuang caves. We call the Dai a minority because they look exotic like foreigners. Not like a Chinese with a Mao jacket, but with very thin bodies and very tropical. They tie their hair in big buns and their clothes are tight so every curve shows. Artists liked to use them as subjects and there is actually a "Yuanan" school of artists.

Water Festival was criticized because the artist used stylized nudity and that caused a big controversy. Of course he used only the female. Finally there was a big political battle and somebody from the government organized the Dai people to write letters to say "How dare you," and "He insulted our people." Anyway the final solution was that they built another wall to cover *Water Festival*.

kmz In what way did your training in mural painting influence your work?

hl I think it came together after I got here, but back then, the reason I was so excited by mural painting was that I saw the possibilities for doing big work in public spaces. I saw the teachers of the older generation who did walls in airports and, because we had the open door policy, there would be more hotels and restaurants and new hospitals for children. That meant that I would have a lot of opportunities to work.

On the other hand, it was a way to stay away from Chinese or Soviet-style Realism. I was thinking of Diego Rivera and José Clemente Orozco at the time. We saw these very big, political public murals and I was excited. They were strong, modern murals; and there was also the ancient Chinese art in temples, caves, and grottos. There were so many possibilities to do the things I liked to do. I dreamed of visiting these places. I couldn't visit Mexico of course, but by entering the mural program I did go to the Dunhuang caves twice.

kmz Did the caves at Dunhuang influence *Bunny Dance* (1994) (cat. 13)?

hl The top of *Bunny Dance* reminds me of the cave niches. In Dunhuang, there are quite a few cave murals dating from the [A.D.] fourth century. The centerpiece is always Buddha and is called the western "pure land," meaning "heaven" in Buddhism. The less important images and characters are flying angels, like servants, in heaven, the pure land. Some are like musicians, and they were painted as portraits. Buddhist decoration doesn't leave any empty space. It covers the entire cave with little cells. Within each cell there is a musician or angel serving them. So when I decided to do *Bunny Dance,* I used a Buddhist decorative motif, which is very subtle, at the top of each arch. You can see the different cells—almost imprisoned, tight spaces.

kmz You said once that the children in *Bunny Dance* are expressing love for Mao, albeit indirectly.[3] Would you equate the children with the angels at Dunhuang?

hl I think the children with the bunny suits are cultural angels. They were supposed to be like angels, but the angels had jobs. They were programmed and even confined to do their tasks.

kmz Are you implying that the children in *Bunny Dance* are prisoners of their system?

hl Not prisoners, more like robots to serve our needs, like soldiers. The original photograph I used for the painting was taken in a kindergarten by a journalist for *Life* magazine. I think somebody probably explained the whole narrative to the photographer. Ironically, on the wall above the dancers is a propaganda poster of all the nationalities of Chinese children having a great celebration, and the child in the center is holding Mao's picture, but it is cut off in the photograph.

kmz There seems to be an assumption that when we look at Chinese art from the mid to late twentieth century, the work must be rooted in politics.

hl Absolutely. That is the expectation of the audience. Whenever you hear an artist from China speak, you assume they are only concerned with political issues. I think that is a burden.

kmz In Margo Machida's essay, "(re) Orienting," she suggests that Asian women are seen as being "dismissable" in the "alleged hierarchy of oppression" because they are perceived as having fewer problems with assimilation.[4] What do you think about that remark?

hl Asian women are from many different cultures. Asia is one of the biggest continents. Even Chinese women are from different backgrounds. Are you talking about Asian women who were born there, live there, or are still there? Or, are you talking about American-born-Chinese? They are all different.

Years ago Margo sent me a questionnaire asking me about feminist issues. I answered by saying I don't like to label myself because when you talk about the American feminist movement, the first wave, the second or whatever, I don't fit into any of them. Although I agree with many things about feminism, I don't know how I fit in.

kmz Why don't you feel your work fits into the category of feminist art? When I think of the prostitute series, and your intent to show the many levels of commodification of women, the agency in them seems directly feminist.

hl It depends on how you define feminist art. Since I'm a woman, I bring certain feminist issues to my work, but it's not the only thing I bring in. I think in the U.S. there is a strong group of women, such as Miriam Schapiro, Suzanne Lacy, or Lucy Lippard, who made history. I know when I came to this country I was influenced by American feminists. I do feel I have freedom here as a woman artist, but when

I worked in China I also felt I was a kind of feminist. Either I was born that way or maybe I was influenced by my mother or grandmother. The matriarchal line in my family is very strong. Perhaps because we had so many "isms" in China, many of which were used as labels to criticize people, I am reluctant to completely adopt the label of "feminist" here.

kmz In your 1997 artist's statement, you said that your work embraces "pastiches of style and clashes of culture that were post-modern before they were modern."[5] Could you elaborate on this comment?

hl Everything is relative. My work is not timeless. It's not universal, forever, self-contained, and never-changing, as if anywhere you take this art, it will be always the same. Rather, it is already broken down, a pastiche of different cultural styles, like the prostitute photographs.

First of all, the photo studio in which the prostitutes were posed is already very artificial, a kind of stage set. Secondly, when they put on western clothes or were rowing the fake boat in *The Raft of the Medusa* (1992) (cat. 7) or driving fake cars, it all looked post-modern to me, a pastiche of design. The photographs gave me a lot of post-modern ideas about fractured identity and transcultural migration. I think it's very important to see that part of them.

In painting, unlike billboards or propaganda illustration, I think I have particular relationships with the image or the subject matter. There is a lot of middle-ground and ambiguity, especially when I use historical photographs. That means I am already using a mediated image. My subjects were already subjects of the camera. They were already fixed in time. The value of photography, I think, is that it is a democracy. In front of the camera, no matter if someone is a slave from Africa or royalty in China, all subjects level out and are the same in the image. Perhaps saying there is democracy and equality in photography is too ideal, but when I use the photographs, I can put the prostitute next to the last empress and, purposefully, sometimes I do this. It's almost like you can't tell the difference unless I tell you the story behind it.

kmz How do you begin a new work or series?

hl I start working in a way that might not be visible to other people. For example, I don't start a new painting the moment I grab the brush and make the first mark. Sometimes I might start on an airplane flight, in mid-air. I always like to bring my source materials with me,

which in my case is a lot of old photographs. I might shuffle them like cards on the airplane. I also like to bring blank paper, a pad, or a sketch book. I look at the photographs over and over. I always look at them so I am very familiar with them.

Then I select or single out those photos that really hit me or that I feel I want to look into very hard, and I start to sketch. I ask myself: If these images were a painting, what would it be like? What kind of shape? Why am I doing this? I start to question myself, and I start to physically move, to go through it, as a way of reading it more carefully. Reading it with the eyes is different than sketching it. And then one idea leads to another. The best moments I have are in mid-air, in the airplane, because I know nobody can reach me, and I am going from one place to the other, so I'm in the middle of nowhere.

kmz In a liminal or transitional state.

hl Exactly. Especially during long flights. I do a lot of drawings, and when I get back, I narrow them down from fifteen drawings to maybe three where I feel strongly about the subject matter and its formality as a potential painting. Also, I get excited about the missing information, the ambiguity: such as, does it look like a man, or is there gender confusion? All of this comes out, like the gate of a dam was lifted.

kmz Recently, you said that "between dissolving and preserving is the rich middle-ground where the meaning of an image is found. The process of painting has become the investigation of a document which stands between history and me."[6] We've already talked about subjective historical interpretation and about what is retained or selectively deleted. How do you perceive your role in historical interpretation?

hl Well, first of all, the photograph was taken a long time ago, in another time, another place, by other people. So it was a historical event, a moment in the long chain of history. And here I am, revealing all these existing images from more than one-hundred years ago, already taken by somebody else. What I do is preserve and dissolve.

In my paintings, the media and the scale are very different. The photograph was taken in real time, in an instant. But for me, my real time is studio time, a slower kind of pace. I try to uncover and preserve the meaning of the photograph, emphasizing and intensifying some parts because in the photograph I saw something really forceful.

In the U.S., the instructors in painting classes always talk about "push and pull," you push something back, you pull something forward. That's about painting technique, but also, psychologically, there is a kind of push and pull. The thing you focus on is important. You try to pull your focus forward as far as possible, and some things that weren't important I wanted to wash away or push back, to dissolve them.

My paintings are also metaphors for memory and history, for how memory sometimes fades or distorts and how we remember things incorrectly. Nobody's memory is accurate, and neither is history because it depends on who is writing it.

kmz In a sense, by isolating or pulling your subjects forward, you are altering the "stage" or original scene that was in front of the photographer.

hl I think staging is very important because it's about performance. Basically when you are on stage it is a frontal view and you project yourself to the audience in front of you, not toward the backstage. That is a way to order things for your audience. They don't care what chaos is backstage, and you don't want to show it to them when you are half-way finished with make-up. You want to give them the best, so I think people stage themselves for the camera, even when they are being "natural."

kmz How does the looseness in the way you handle paint relate to "the crazy Chinese landscape painters"?[7] Could you tell me more about this tradition?

hl Actually, that goes back to graduate school in San Diego with Allan Kaprow, who was my adviser. When we met in my studio we never discussed how to do paintings, but we talked a lot about stories or told jokes. Once, we talked about a crazy Chinese traditional painter and calligrapher who put a giant sheet of rice paper on the floor. Long ago, men all had long hair and they tied it up. This painter dipped his queue in a big bucket of ink and started with his hair and then later his body (after a few drinks, of course), and then he put his head on the paper and smeared it, like an ancient Chinese Jackson Pollock.

In Chinese tradition, even in some of our lives, there is that moment of setting your spirit free to do art work, to write poems or to make music. I feel rooted in this aspect of my culture. We always look at the west and modern art to set everybody free. Maybe some of that, for me, is rooted in China as well.

kmz What did you mean when you said that Allan Kaprow taught you "how to think, not how to paint, and to ask what does being an artist mean"?[8]

hl I think it's a long-term transformation for me. It's not just the cultural shock of this country. I felt perfectly fine and comfortable coming here. But later, when I looked back to when I first came to the U.S. for graduate school in 1984, it did shock me in a very fundamental way. Like, what is art? What belongs to the art world? Somebody made the point: if it's not functional, it has to be art. I wasn't so sure.

For one project, Allan took us to a giant dumpster. He brought an old chair and buckets of paint and said go ahead and do something, and I was at a complete loss. Should I do a painting? Because the way I was trained in graduate school [in China] was to start with the subject matter, with what the art work means. I was just standing there; I didn't know what to do, and he didn't give concrete instructions. And then there was a young guy, who opened the buckets and poured some paint onto the chair, and messed it up. I thought, OK, I can do that. What changed was how to unlearn a lot of things. In China everything had to be arranged and planned well, the cool colors next to the warm because we were trained that way, almost like paint-by-numbers. Those numbers were already programmed in my head.

In the most recent paintings I felt like when I was in front of the dumpster many years ago. Like I was going to do this with no concrete plan or idea. It was like, here, just brush to see what happens. Although these paintings are based on historical photographs, I also wanted to create some part of the old furniture or piece of junk. I remember the moment when that young man poured the paint. The moment, the gesture. On the one hand, I try to think through my work, yet when I am really in concert with my canvas physically, I want to be in it, to perform; I'm on stage but I don't have to literally memorize every single line of the script. I'm into it.

kmz What led you to select Tibetan subjects for some of your 1997 paintings?

hl First of all, the subject matter is the Tibetans along the border of China. A lot of minorities and nationalities live there. I feel I should know them because they are part of China; but, in fact, I don't know them any better than I know some Americans. The border is psychological and shifts from one side to another because you can cross a borderline and then you become the Other. Now I feel the border is becoming more and more blurry, not just for me, but in the world today. It's very hard to draw a clear border.

Yoke (1997) (cat. 24) depicts a Tibetan criminal wearing a wooden headboard around his neck, a pretty heavy board and a strong punishment. He will be in this situation for five years. The board was so big that his hands couldn't reach his mouth so he couldn't feed himself, and he had to depend upon the mercy of monks. I think the reason I probably decided to paint it was because I felt the board was very much like a canvas.

kmz A canvas within a canvas?

hl A surface upon a surface. The surface of the board becomes the painting surface. It's his board but my canvas. It could be a psychological self-portrait because my marks are all there on his board and on my surface. The whole thing is tightly confined into a limited square space. The board tilts a little, and all you have is a suspended head without a body. Of course, the person is anonymous and it's hard to tell if it is a man or a woman—I think it's a man—still, there is an ambiguity. And what nationality is this person? He or she could be from a number of places yet this person was punished by the Tibetans, by his own kind, not by the Communist Party. That part is very interesting. If I say this is a Tibetan, American viewers automatically think "human rights," or "the Communist Party." But it's not that simple.

kmz Given the emphasis of the last ten years or so in this country on multiculturalism, do you think your work, and by extension, yourself, might be prey to the desire and attraction of the West at the end of the twentieth century for the perceived authenticity of the cultural Other? This permutation of cultural appropriation is actually the subject of some of your work.

hl I see this from two sides. For myself, of course I'm Chinese from China. But I am also living here; this is my new home. I'm comfortable dealing on a daily basis with an American multi-cultural, multi-racial, or multi-layered high-speed reality. I feel I am not just a simple noun, "Chinese-American." I think it's more of a verb, like "Chinese-becoming-American." It's probably a long process throughout the rest of my life, and there won't be an end.

Although I know a lot, maybe more than a lot, about China and Chinese culture, I never felt comfortable claiming that I represent Chinese culture or even a little part of Chinese history. I am an individual, and although I have a lot in common with my generation of Chinese who either came to the West or are still in China, I feel I should never be so arrogant as to say, "Well, I'm Chinese, I represent China." I represent only myself and my particular collage of experiences.

kmz What is the history behind *Boxer Rebellion* (1996) (cat. 23)?

hl There was a photograph I'm very familiar with of the Boxer Rebellion that showed Japanese soldiers who executed several of the Boxers. So I focused on the severed heads.

In 1900, after the Opium War, a lot of foreigners appeared in China, including missionaries. That was a threat to a lot of Chinese. Among the Chinese, there is a nasty term for foreigners, especially white foreigners because they were considered "foreign devils," like today's aliens. The aliens are the Others. After the Opium War, China lost Hong Kong and Macao which became colonies, and because of that, more ports were opened for trade. Some Chinese, mainly men, realized that they had to defend China against the foreign devils. It started with the martial arts groups who got together to practice Guongfu; a boxer is one kind of martial artist. Using that formality they organized the uprising. And, of course, it was suppressed by the Ch'ing government, the last dynasty. The last emperor actually was too young to be involved, but the empress dowager, using the foreign troops, completely wiped out the Boxers. So a lot of them were executed in public, and their severed heads were put on display to scare people.

kmz	Is *Daughter of the Revolution* (1993) (cat. 8) a self-portrait?
hl	As I said, during the Cultural Revolution, I had a camera and I posed secretly. Maybe like Cindy Sherman! (Actually, it was a kind of self-indulgence.) So, I took my picture with a scarf and lace tablecloth imitating, I think, the kind of western bourgeois identity we were then criticizing—I was staging my own private little cultural revolution, a kind of dangerous thing to do with a camera, really. I was secretly taking my own photograph and appreciating who I was. I was trying to capture and keep a piece of myself during the revolutionary time.

Because of the title, it doesn't have to be me. I found the bottle that sits in front of the painting at an antique shop, and it's stamped with the image of George Washington under the phrase "The Father of His Country." It's very funny because it doesn't look like Washington, but I like the term—the father of something. So I'm the daughter of what? Of the revolution! All I had at home was revolution. |
kmz	*See-Saw* (1994) (cat. 14) seems to reference your moving between your dual realities.
hl	That painting was based on old magazine photographs from the twenties or thirties in pre-Communist China. The young women looked like high school girls. They were performing some kind of dance and the costumes were sleeveless and very short like mini-skirts—very provocative for that time. The newspaper of the time would make a big deal about it if women exposed themselves too much. Women used to have to cover their entire body, from head to toe. There's a story about a man who touched a woman's hand (not his wife's), and she cut her hand off because it was dirty. So, when I saw this kind of costume that exposed their arms and legs with bare feet, it was both avant-garde and generic. It could be any country, anywhere. Symbolically, the dancing forward is like testing the social water; it's like being on a see-saw. It also portrays a tension or balance between figuration and abstraction, which is symbolic of my transformation from Chinese art to American art.
kmz	*The Last Dynasty* or "court" series was painted in 1995. Tell me about *Five Eunuchs* (1995) (cat. 20).
hl	*Five Eunuchs* is one of my favorite paintings, really. The reason is not just because of the subject matter. The subject matter was important, but when I looked at the photograph, the only powerful person was a woman—the old lady in the middle. All the men

serving her were not full men, because they were castrated. I read in some books about the court, the corruption, and the eunuchs. At that time, I was a little confused about when the Chinese eunuchs were castrated and what part was removed. Later I learned everything was removed, and many died because it wasn't done with anything close to today's medical standards, and they didn't use anesthesia. It was a very brutal tradition.

I started the painting with a lot of passion because there are so many figures. It also, in an odd way, reminded me of the Red Guards, like a mass worshipping of one leader. I decided to insert five cigar boxes into the canvas surface. They're from a friend's collection. She collected them for years and gave them to me. I used the boxes because of a historical detail about castration: the eunuchs had to save their severed parts and put them in a container on the upper level of a shelf, the higher the better to symbolize promotion in their futures. When they died, they were supposed to be buried with the severed parts for the next life, where they will once again be whole men.

kmz Why was *Goddess of Love, Goddess of Liberty* (1989) (cat. 2) such an important painting for you?

hl It was a breakthrough painting, and it happened after the Tiananmen Square uprising. During that time, I saw a lot of images of what Chinese artists called a "Goddess of Freedom." It was an imitation of the Statue of Liberty, a strong woman with a torch, and I couldn't do anything to show the feeling. I had a photograph from around 1900 of a woman exposing her bound feet before a foreigner's camera (fig. 2), and I said, "Well, she represents the true condition of liberty in China." It was such a painful image and so straightforward. She's just giving up, surrendering.

In old China, when women showed their feet, it was considered provocative and pornographic, but she's showing her feet to a camera, to the outside world! I felt the first time I painted this woman was a breakthrough, not just because of the hot subject matter, the story of women's foot binding, but also because of the way I painted. I felt I painted very well. You know she wears almost classical drapery, and because of the white clothes, I felt she was a holy figure, like a goddess. The title is ironic, of course, but overall I treated her like a goddess.

kmz I understand there is an interesting story connected with *The Ocean is the Dragon's World* (1995) (cat. 22). What does the title mean?

hl The reason I used this title was because the dragon represents kingly power, and is only used for males. When the empress dowager took over power (the phoenix is the royal female symbol) she reversed the whole thing. She even literally asked the craftsmen to switch the yin/yang design. Normally there is a dragon on top, but she asked that the phoenix be on top. So I felt only an empress can try to play the same role in a patriarchal society. I purposely painted her with heavy robes, very formal with props and everything. All her decoration is taking over, and the opulence is to show power, but ironically, she disappears into it.

The National Museum of American Art in Washington, D.C., which owns *The Ocean is the Dragon's World,* also has a portrait of the empress dowager in its collection, done by an American woman painter in 1903, ninety-five years ago. This American painter, Katherine Carl, was commissioned by the empress dowager to do her portrait, and Carl moved into the palace. One day the dowager selected what would be the perfect day to start, and Katherine Carl made her first marks on canvas, and very soon the dowager got impatient because it was so boring to sit there, so she asked her servant to put on her robes and pose in her place.

After a while she started criticizing the painting. She said, "My pearls are the best in the world; why are you painting them various colors? Look at my pearls; they are so pure." And then she criticized the face Katherine Carl did. "Why is this part dark? My face is perfect, clean." Any shadow was bad luck as she was very superstitious. So, according to this dragon-lady's "art criticism," the American painter had to change everything and make the pearls so round, make her face so perfect. This painting came to the U.S. and was shown in the 1904 Louisiana Purchase Exposition in St. Louis, Missouri, and ended up in Washington, D.C. So I felt the contrast was ironic. Carl was American. She had nothing to do with the Chinese government. She didn't have to obey, but she was commissioned by the Chinese dowager, so she had to do everything that the dowager asked her to do.

As a Chinese working from photographs, I have all the freedom I want. Almost a century apart, and you might assume the Chinese artist would be restrained by a lot of rules, be confined and repressed and scared, but it is exactly the opposite.

Notes

1 Chuang Tzu, *The Complete Works of Chuang Tzu,* trans. Burton Watson (New York: Columbia University Press, 1968), 49. "That is, to ordinary men the shadow appears to depend upon something else for its movement, just as a snake depends on its scales (according to Chinese belief) and the cicada on its wings. But do such casual views of action really have any meaning?"

2 Hung Liu in conversation with the author, January 1998.

3 Trinkett Clark, *Parameters: Hung Liu* (Norfolk, Virginia: Chrysler Museum of Art, 1996), exhibition brochure.

4 Margo Machida, "(re) Orienting," *Harbour* 1 (August-October 1991): 37-38.

5 Hung Liu, Oakland, California, to Kathleen McManus Zurko, Wooster, Ohio, February 1997.

6 Ibid.

7 Hung Liu, "Hung Liu: Works in Progress," for *A World of Art,* Henry Sayre, 25 minutes, Oregon Public Broadcasting Company, The Annenberg/C.P.B. Project, 1996, videocassette.

8 Lisa G. Corrin, "In Search of Miss Sallie Chu," *Hung Liu's Can-ton: The Baltimore Series* (Baltimore, Maryland: The Contemporary, 1995), exhibition brochure.

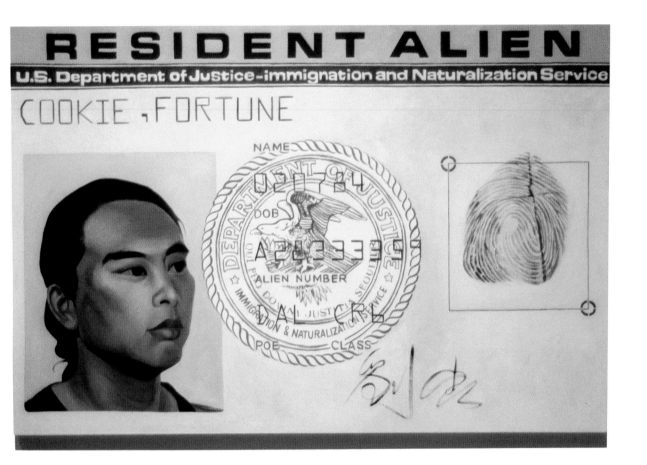

1 **Resident Alien,** 1988
 oil on canvas
 60 x 90 inches
 Courtesy of Steinbaum Krauss Gallery,
 New York, New York

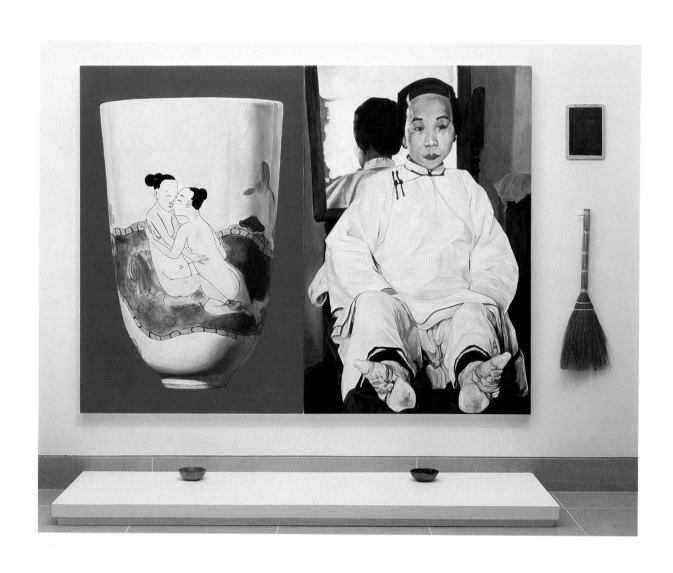

2 **Goddess of Love, Goddess of Liberty,** 1989
oil on canvas, mixed media
72 x 96 inches
Dallas Museum of Art, Dallas, Texas
Museum League Purchase Fund 1990.91

3 **A Tale of Two Women,** 1991
oil on canvas, mixed media
60 x 60 x 12 inches
Collection of San Jose Museum of Art,
San Jose, California
Gift of Rena Bransten, California

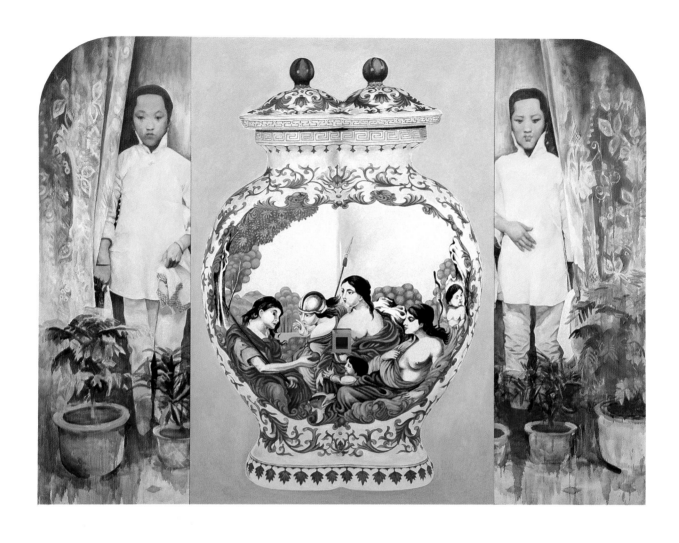

4 **Judgment of Paris,** 1992
oil on canvas, lacquered wood
72 x 96 x 4¾ inches (triptych)
Courtesy of the artist and the
Rena Bransten Gallery,
San Francisco, California

福 玉

5　**Mona Lisa II,** 1992
oil on canvas, antique architectural panels,
lacquered wood
42 x 30 inches
Collection of Frances Elk Scher, New Jersey

6　**Madonna,** 1992
oil on canvas, gold leaf,
antique architectural panel
80 x 40½ inches
Collection of Esther S. Weissman, Ohio

7 **The Raft of the Medusa,** 1992
 oil on canvas, lacquered wood, mixed media
 61 x 96 x 8½ inches (diptych)
 Collection of Barbara and Eric Dobkin, New York

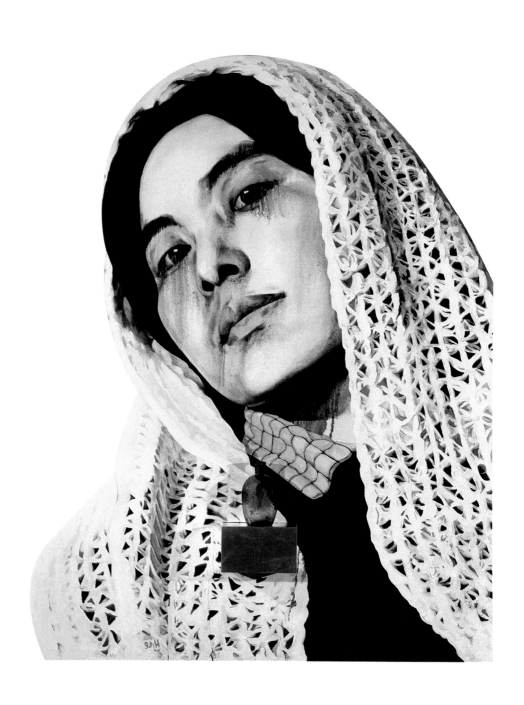

8 **Daughter of the Revolution,** 1993
oil on canvas, silver leaf on wood, glass bottle
78½ x 62 x 5½ inches
Collection of Hung Liu and Jeff Kelley, California

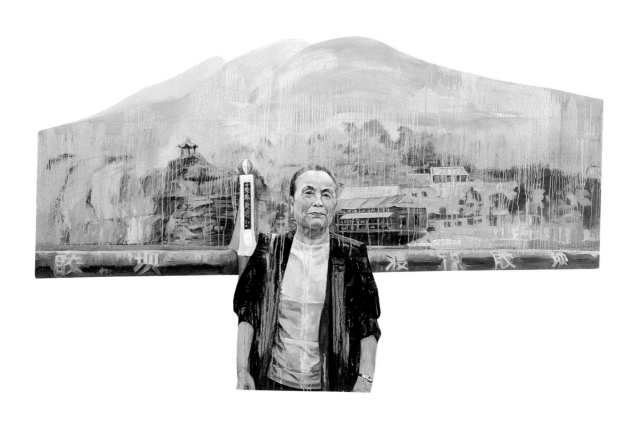

9 **Ma,** 1993
oil on canvas
59 x 96 inches
Courtesy of Steinbaum Krauss Gallery,
New York, New York

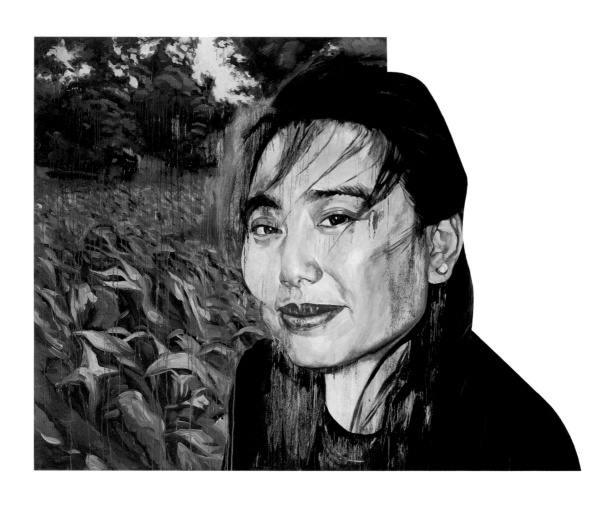

10 **Burial at Little Golden Village,** 1993
oil on canvas
74 x 96 inches
Collection of Bernice and Harold Steinbaum,
New York

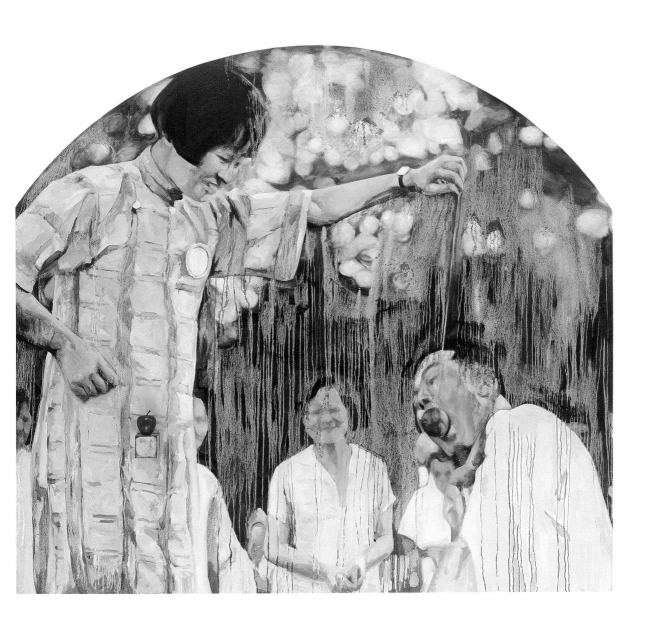

11 **Apple Shrine,** 1993
oil on canvas, painted wood, marble apple
71½ x 80 x 3 inches
Collection of Esther S. Weissman, Ohio

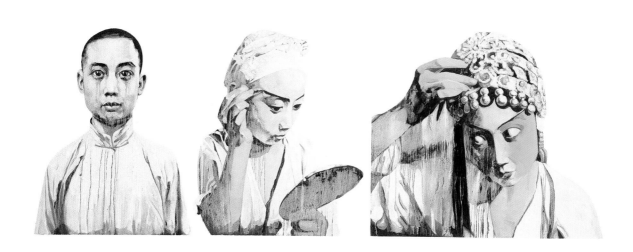

12 **Blue Boy,** 1993
oil on canvas
48 x 145 inches (triptych)
Collection of Barbara and Eric Dobkin,
New York

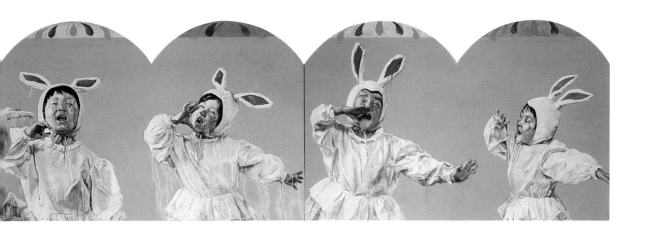

13 **Bunny Dance,** 1994
oil on canvas
46 x 144 inches (diptych)
Courtesy of Steinbaum Krauss Gallery,
New York, New York

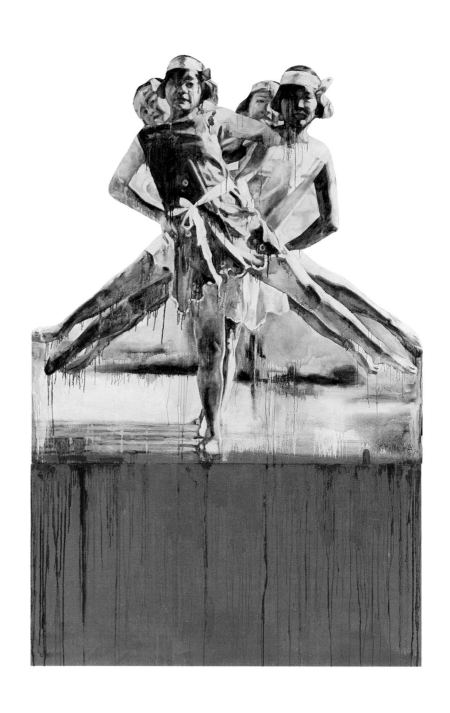

14 **See-Saw,** 1994
oil on canvas
108 x 72 inches
Courtesy of Steinbaum Krauss Gallery,
New York, New York

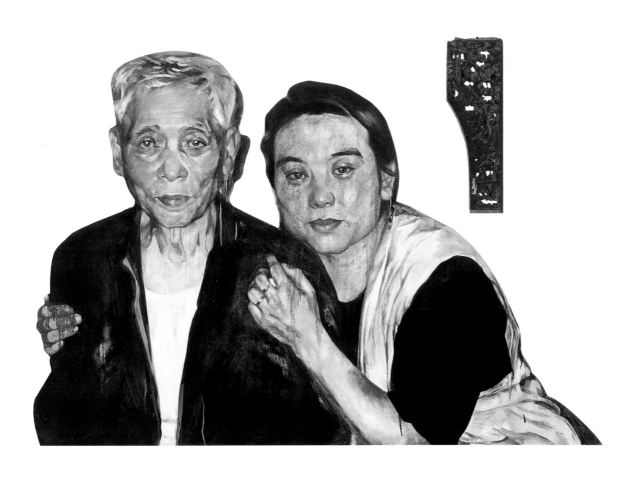

15 **Father's Day,** 1994
oil on canvas, architectural panel
54 x 72 inches
Collection of Bernice and Harold Steinbaum,
New York

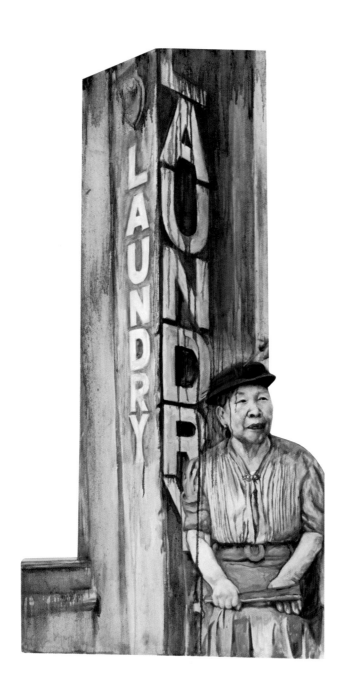

16 **Laundry Lady,** 1995
oil on canvas
72 x 38 inches
Collection of Aaron and Marion Borenstein,
Indiana

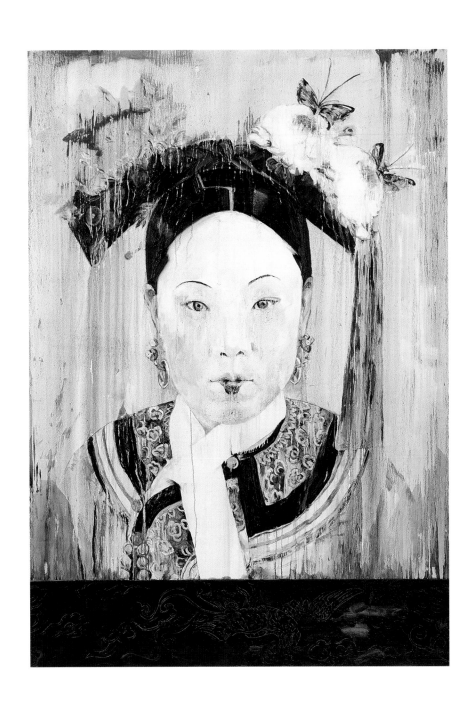

17 **Cherry Lips,** 1995
oil on canvas
84½ x 60 inches
Collection of Nancy and Peter Gennet,
California

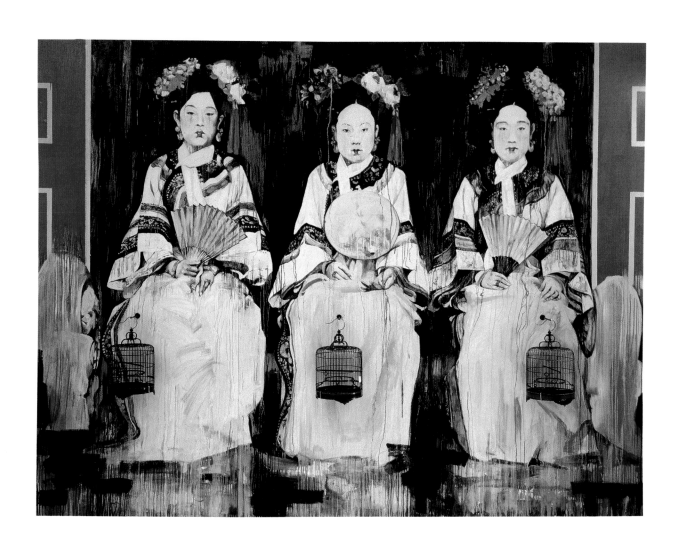

18 **Three Fujins,** 1995
oil on canvas, three bird cages
96 x 126 x 12 inches (triptych)
Collection of Ellen and Gerry Sigal,
Washington, D.C.

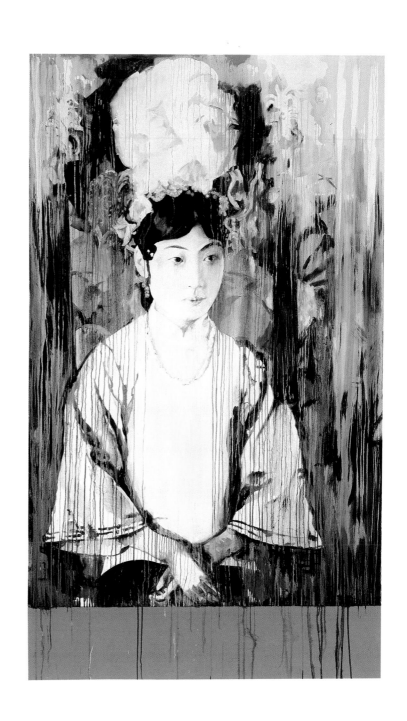

19 **The Last Empress,** 1995
oil on canvas
103 x 60 inches
Collection of Aaron and Marion Borenstein,
Indiana

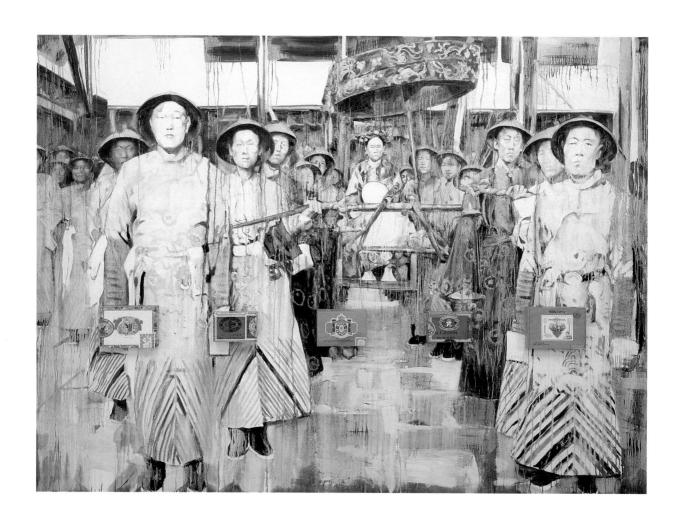

20 **Five Eunuchs,** 1995
 oil on canvas, mixed media
 70 x 96 x 4 inches
 Collection of Bernice and Harold Steinbaum,
 New York

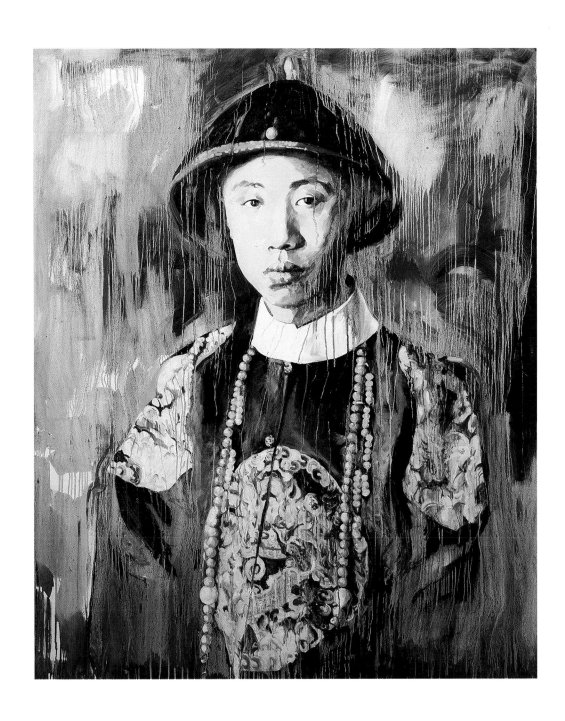

21 **Baby King,** 1995
oil on canvas
72 x 60 inches
Collection of Penny and Moreton Binn,
New York

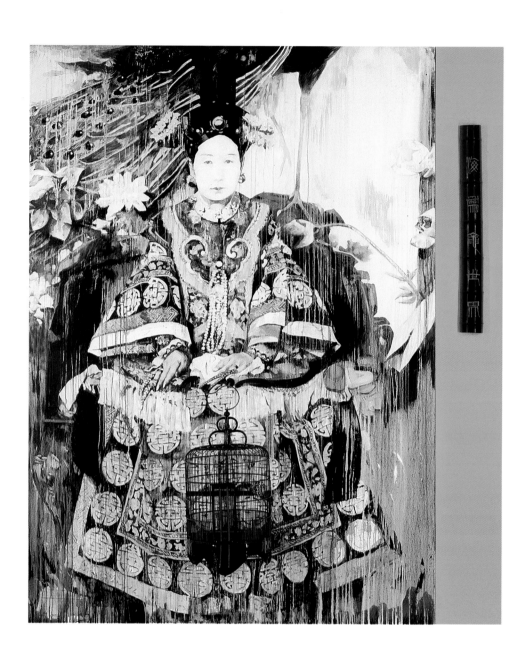

22 **The Ocean is the Dragon's World,** 1995
oil on canvas, painted wood panel, metal rod,
and metal bird cage
96 x 82½ inches
National Museum of American Art,
Smithsonian Institution, Washington, D.C.
Museum purchase in part through the
William R. and Nora H. Lichtenburg Foundation

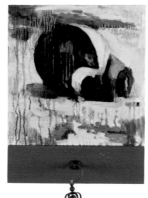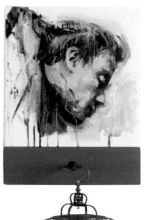

23 **Boxer Rebellion (Group I),** 1996
oil on canvas, three bird cages
36 x 18 x 9 inches each
Courtesy of Steinbaum Krauss Gallery,
New York, New York

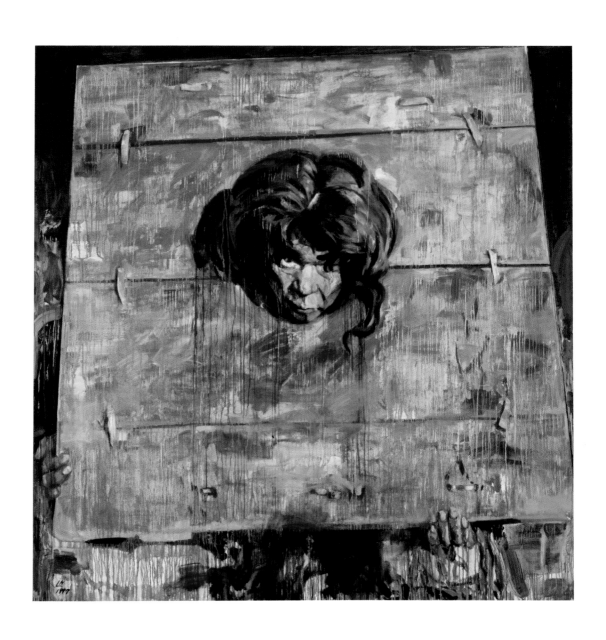

24 **Yoke,** 1997
oil on canvas
80 x 80 inches
Collection of Esther S. Weissman, Ohio

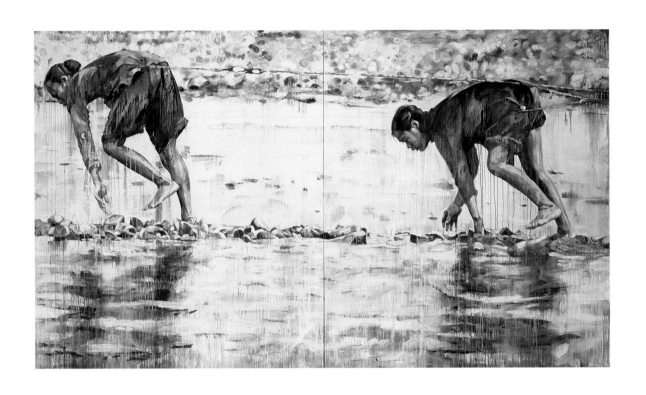

25 **Mu Nu (Mother and Daughter),** 1997
oil on canvas
80 x 140 inches (diptych)
Kemper Museum of Contemporary Art,
Kansas City, Missouri
Purchased with funds of the
Kemper Museum of Contemporary Art, 1997.22 a-b

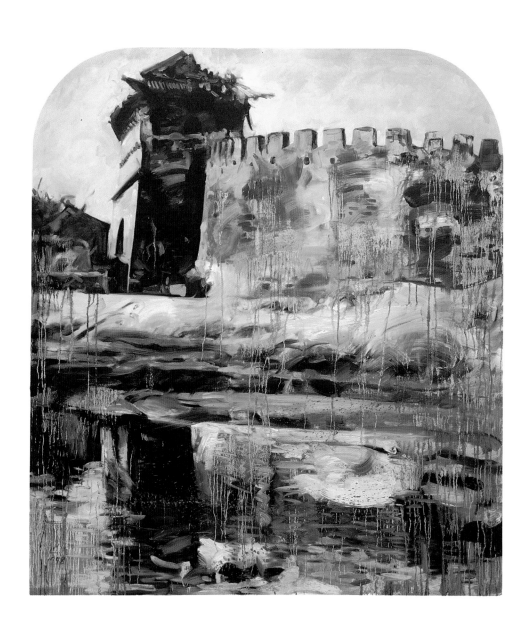

26 **The Old Capital I,** 1998
oil on canvas
68 x 60 inches
Courtesy of the artist and the
Rena Bransten Gallery,
San Francisco, California

●

In painting, unlike billboards or propaganda illustration, I think I have particular relationships with the image or the subject matter. There is a lot of middle-ground and ambiguity, especially when I use historical photographs. That means I am already using a mediated image. My subjects were already subjects of the camera. They were already fixed in time. The value of photography, I think, is that it is a democracy. In front of the camera, no matter if someone is a slave from Africa or royalty in China, all subjects level out and are the same in the image. Perhaps saying there is democracy and equality in photography is too ideal, but when I use the photographs, I can put the prostitute next to the last empress and, purposefully, sometimes I do this. It's almost like you can't tell the difference unless I tell you the story behind it.

H. L. 1997

73

1 **Resident Alien,** 1988
 oil on canvas
 60 x 90 inches
 Courtesy of Steinbaum Krauss Gallery,
 New York, New York

2 **Goddess of Love, Goddess of Liberty,** 1989
 oil on canvas, mixed media
 72 x 96 inches
 Dallas Museum of Art, Dallas, Texas
 Museum League Purchase Fund 1990.91

3 **A Tale of Two Women,** 1991
 oil on canvas, mixed media
 60 x 60 x 12 inches
 Collection of San Jose Museum of Art,
 San Jose, California
 Gift of Rena Bransten, California

4 **Judgment of Paris,** 1992
 oil on canvas, lacquered wood
 72 x 96 x 4¾ inches (triptych)
 Courtesy of the artist and the
 Rena Bransten Gallery,
 San Francisco, California

5 **Mona Lisa II,** 1992
 oil on canvas, antique architectural panels,
 lacquered wood
 42 x 30 inches
 Collection of Frances Elk Scher, New Jersey

6 **Madonna,** 1992
 oil on canvas, gold leaf,
 antique architectural panel
 80 x 40½ inches
 Collection of Esther S. Weissman, Ohio

7 **The Raft of the Medusa,** 1992
 oil on canvas, lacquered wood, mixed media
 61 x 96 x 8½ inches (diptych)
 Collection of Barbara and Eric Dobkin, New York

8 **Daughter of the Revolution,** 1993
 oil on canvas, silver leaf on wood, glass bottle
 78½ x 62 x 5½ inches
 Collection of Hung Liu and Jeff Kelley,
 California

9 **Ma,** 1993
 oil on canvas
 59 x 96 inches
 Courtesy of Steinbaum Krauss Gallery,
 New York, New York

10 **Burial at Little Golden Village,** 1993
 oil on canvas
 74 x 96 inches
 Collection of Bernice and Harold Steinbaum,
 New York

11 **Apple Shrine,** 1993
 oil on canvas, painted wood, marble
 71½ x 80 x 3 inches
 Collection of Esther S. Weissman, Ohio

12 **Blue Boy,** 1993
 oil on canvas
 48 x 145 inches (triptych)
 Collection of Barbara and Eric Dobkin, New York

13 **Bunny Dance,** 1994
 oil on canvas
 46 x 144 inches (diptych)
 Courtesy of Steinbaum Krauss Gallery,
 New York, New York

14 **See-Saw,** 1994
 oil on canvas
 108 x 72 inches
 Courtesy of Steinbaum Krauss Gallery,
 New York, New York

15 **Father's Day,** 1994
 oil on canvas, architectural panel
 54 x 72 inches
 Collection of Bernice and Harold Steinbaum,
 New York

*Dimensions are in inches. Height precedes
width and depth.*

16 Laundry Lady, 1995
oil on canvas
72 x 38 inches
Collection of Aaron and Marion Borenstein,
Indiana

17 Cherry Lips, 1995
oil on canvas
84½ x 60 inches
Collection of Nancy and Peter Gennet,
California

18 Three Fujins, 1995
oil on canvas, three bird cages
96 x 126 x 12 inches (triptych)
Collection of Ellen and Gerry Sigal,
Washington, D.C.

19 The Last Empress, 1995
oil on canvas
103 x 60 inches
Collection of Aaron and Marion Borenstein,
Indiana

20 Five Eunuchs, 1995
oil on canvas, mixed media
70 x 96 x 4 inches
Collection of Bernice and Harold Steinbaum,
New York

21 Baby King, 1995
oil on canvas
72 x 60 inches
Collection of Penny and Moreton Binn,
New York

22 The Ocean is the Dragon's World, 1995
oil on canvas, painted wood panel, metal rod,
and metal bird cage
96 x 82½ inches
National Museum of American Art,
Smithsonian Institution, Washington, D.C.
Museum purchase in part through the
William R. and Nora H. Lichtenburg Foundation

23 Boxer Rebellion (Group I), 1996
oil on canvas, three bird cages
36 x 18 x 9 inches each
Courtesy of Steinbaum Krauss Gallery,
New York, New York

24 Yoke, 1997
oil on canvas
80 x 80 inches
Collection of Esther S. Weissman, Ohio

25 Mu Nu (Mother and Daughter), 1997
oil on canvas
80 x 140 inches (diptych)
Kemper Museum of Contemporary Art,
Kansas City, Missouri
Purchased with funds of the
Kemper Museum of Contemporary Art, 1997.22a-b

26 The Old Capital I, 1998
oil on canvas
68 x 60 inches
Courtesy of the artist and the
Rena Bransten Gallery,
San Francisco, California

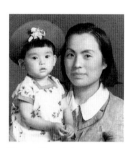

Hung Liu with
mother in Changchun,
1949.

1948 Hung Liu was born February 17th (January 8th on the Chinese calendar, Year of the Rat) in Changchun, China. Changchun had been the capital city for the Japanese puppet dynasty of the exiled "Playboy" Emperor Pu Yi.

Changchun is defended by the Nationalist Army (the Kuomintang) of Chiang Kai-shek from the advance of Communist forces led by Lin Biao and Mao Tse Tung. Liu's father, Xia Peng, is a captain in the Kuomintang army. Starvation and panic ensue after months under siege, despite attempts by American planes to drop food and supplies into the city.

In September, the family flees the city looking for food, crossing over into Communist territory. Liu's father is detained by Communist troops at a checkpoint outside Changchun. She will not see him again until 1994.

Seeking refuge, the remaining family—Liu, her mother, aunt, uncle, and grandparents—make their way to Jilin, a nearby city, and then to a village in the Manchurian countryside where the name "Liu" predominated.

Changchun falls to the Communists in October. Soon after, the family returns to Changchun, "the dead city."

1954 Liu begins school at a Kindergarten for teachers' children. Her mother, Liu Zong Guang, is a middle school teacher.

1955 Liu begins elementary school.

1957 Mao Tse Tung initiates the "Great Leap Forward," an attempt to catch up with the West in agricultural and industrial production.

1959 Liu, age eleven, decides impulsively at the Changchun train station to accompany her aunt, Liu Zong Yu, to Beijing (where her aunt had lived since 1956). Her mother allows her to go with only "the clothes on her back."

1960 Liu's grandparents and mother follow her to Beijing, where they will permanently reside together.

A mass famine, the result of Mao's disastrous "Great Leap Forward," grips the nation.

1961 Because of high exam scores, Liu enters a special "experimental" girls' boarding school in Beijing, the Girls Middle School Attached to Peking Normal University. Her schoolmates include the daughters of Deng Xiaoping and Liu Shao Qi, as well as children of other high Party officials. (Mao's daughters had attended several years earlier.) Liu remains, performing at the top of her class, until 1966.

1962 The famine begins to ebb in the cities.

Chinese/Soviet relations deteriorate.

Liu's grandfather—a scholar of the monasteries of Mount Qian in Manchuria—dies.

1966 As Liu is about to graduate from high school, the Cultural Revolution (which will continue for ten years) begins. Millions of youthful Red Guards are unleashed by Mao in an effort to purge Chinese society of Western, "counter-revolutionary" influences.

Schools close. Liu is unable to receive her diploma.

Liu's aunt, Liu Zong Yu, has her head shaved in public for having joined the Nationalist Party during the 1920s.

Mao decrees free train travel for young people. Although not a Red Guard, Liu rides the trains throughout China: to Xinjiang, Guangzhou, Harbin, Dalian, Shanghai, and Tianjin.

1968 Liu is sent for proletarian "re-education" among the peasants in the countryside. There, she works in rice and wheat fields seven days a week for four years. She also photographs and draws portraits of local farmers and their families.

1972 Schools begin to reopen. Liu enters the Revolutionary Entertainment Department of Beijing Teachers' College to study art and art education.

Nixon arrives in China.

1975 Liu graduates and begins teaching art at the Jingshan School, an elite Beijing school modeled after the Russian system (first grade through tenth).

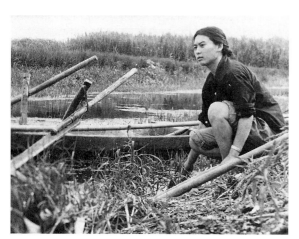

Liu at Baiyangdian, a river village, in the mid-1970s.

Asked to teach children's art on national television, Liu gives weekly lessons from the studios of the Central China Television station, attaining an unexpected fame (and receiving numerous written proposals of marriage). Her program, *How to Draw and Paint,* lasts several years.

1976 Zhou En Lai dies. Liu is among thousands who take wreaths of paper flowers to Tiananmen Square, nearly covering it. By the next morning, the flowers had been swept away by the authorities.

Liu travels to northern China with a group of school art teachers. There, she experiences the great Tang Shan earthquake in which perhaps a million people were killed.

Mao Tse Tung dies. His body lies in state, and Liu is among the millions who pass by in procession.

The Gang of Four, including Mao's widow, Jiang Qing, is arrested.

1977 At age twenty-nine, Liu marries an astronomer. They separate within a year.

1978 Liu gives birth to a son, Ling Chen.

Deng Xiaoping emerges as the Paramount Leader of China.

The "Open Door Policy" toward the West is established.

1979 After taking national entrance exams, Liu is accepted by the two leading art schools in China: The Central Academy of Arts and Crafts and the Central Academy of Fine Arts. She decides to attend the latter, majoring in mural painting.

Liu travels to the famous Buddhist cave murals at Dunhuang, in the Gobi Desert along the Silk Road. During her several weeks stay, she falls ill and nearly dies, perhaps from drinking local water. She is transported back to Beijing, where she recovers after several months.

Liu's grandmother, Wang Ju Shou, dies in the family's Beijing apartment.

1980　Liu returns to Dunhuang, where she studies and copies the Buddhist cave murals for forty days. She also visits various famous religious shrines throughout China.

Liu begins work on *Music of the Great Earth,* a graduation mural project designed for the Foreign Students' Dining Hall of the Central Academy of Fine Arts.

She applies to the University of California, San Diego, for admission to graduate school in the Visual Arts Department.

Liu divorces her husband (divorces were still uncommon in China).

1981　Liu completes *Music of the Great Earth,* and begins teaching at the Central Academy.

She is accepted to the University of California, San Diego, for the fall quarter, but her bid for a passport is refused by the Chinese government.

The University of California, San Diego, holds her application open.

1982　Liu studies traditional calligraphy and stamp-making from Niu Jun, an aging scholar and Peking Opera playwright. She continues for three years.

She continues teaching at the Central Academy of Fine Arts.

1984　Liu gets a limited passport for temporary travel to Hong Kong in the hope that it will be easier to get from there to the United States. While in Hong Kong, she receives word from the Chinese Cultural Ministry that her request for a passport has been granted, and she returns to Beijing.

On October 26, Liu boards a China Air 747 in Beijing and departs for San Francisco. At the airport she bids farewell to her mother, aunt, and son. It is the first time she's ever been on an airplane. She arrives at San Francisco International Airport with two suitcases and $20, spending $1 to rent a luggage cart before flying on to San Diego.

Liu in graduate school,
Central Academy of Fine Arts,
Beijing, 1979-1981.

Liu in Shanghai
preparing to leave for the
U.S.A., 1984.

Liu begins her graduate studies at the Visual Arts Department of UCSD. Halloween is the first American party she attends.

At UCSD, Liu meets Moira Roth, Allan Kaprow, Eleanor and David Antin, Sheldon Nodelman, Helen Mayer Harrison and Newton Harrison, Manny Farber, and Patricia Patterson, as well as fellow graduate students Lorna Simpson, Christine Tamblyn, Hal Fisher, and Jeff Kelley (her future husband).

1985

Liu participates in making a "dumpster" environment and in several Happening-type events with Allan Kaprow.

She travels around the western states with Kelley, and has a residency at the Sun Valley Center for the Arts and Humanities in Idaho. In November, she has her first one-person exhibition at the Sheppard Gallery, University of Nevada, Reno, where she uses the whole space for a mural-installation based on the ancient grotto caves of Dunhuang.

1986

Liu visits New York and its museums, seeing important works of Western art for the first time.

In the spring, she completes a mural, *Up and Tao*, in a USCD stairwell. In the summer, she marries Kelley at a friend's house in San Antonio, Texas. Her son, accompanied by her mother and aunt, arrive in San Diego and live with her throughout the fall.

At year's end, Liu has her graduate exhibition of variously sized white boxes and standing screens painted with traditional Chinese cloud forms. The family moves to Arlington, Texas, where Kelley takes a teaching job at the University of Texas at Arlington.

1987

Liu teaches a Chinese art history course at the University of Texas at Arlington. She also works as an artist-in-residence for the public schools of east Texas.

She paints at home in a "family room" studio, and has several Dallas/Fort Worth area exhibitions and installations.

Liu's mother and aunt return to Beijing. Her son, Ling Chen, remains.

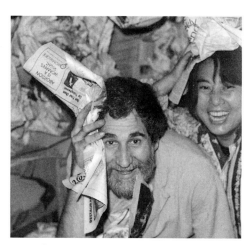

Liu and Allan Kaprow at the University of California, San Diego, 1985.

1988 Liu spends the summer as a resident artist at the Capp Street Project in San Francisco. She produces a mural, *Reading Room,* for the community room of Chinese for Affirmative Action in Chinatown, and creates an installation with paintings, *Resident Alien,* the culmination of her research into the history of Chinese immigration to California.

She completes *Where Is Mao?,* an installation of 1,000 felt cut-outs of Mao's profile, each with a fortune cookie on top, at the Southwestern College Art Gallery in Chula Vista, California.

1989 In the spring, students in Beijing begin assembling in Tiananmen Square, resulting, on June 4th, in their forced removal by the People's Liberation Army. These events serve as inspiration for Liu, who borrows an old, turn-of-the-century photograph of a Chinese woman whose feet were bound (from friend and fellow artist Jim Pomeroy) and completes the painting *Goddess of Love, Goddess of Liberty.*

She receives her first National Endowment for the Arts Painting Fellowship and, in December, has a debut exhibition of paintings in New York.

Liu is offered a teaching position in the Art Department at the University of North Texas, Denton, Texas.

1990 In the spring, Liu is offered a position with the Art Department of Mills College, in Oakland, California. Before moving from Texas to California, she travels throughout Europe, visiting the Venice Biennale, where Robert Rauschenberg, who was being honored at the Russian Pavilion, signs his name on her Chinese passport, offering her "a passport to the art world."

Liu begins teaching at Mills.

1991 Liu receives her second National Endowment for the Arts Painting Fellowship and begins showing at the Rena Bransten Gallery in San Francisco and the Bernice Steinbaum Gallery in New York City.

She returns to China for the first time since leaving, and discovers a trove of old turn-of-the-century photographs of Chinese prostitutes which she begins using as references for her paintings.

With her son, Liu becomes a U.S. citizen.

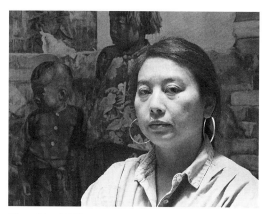

Hung Liu, 1997
Photograph: Jeff Kelley

1992 Liu completes *Map No. 33,* a major installation/mural project for the Moscone Convention Center in San Francisco.

1993 Liu participates in the *43rd Biennial Exhibition of Contemporary American Painting* at the Corcoran Gallery of Art in Washington, D.C.

She travels again to China in search of more archival photographs.

1994 Liu participates in *Asia/America: Identities in Contemporary Asian American Art* at the Asia Society in New York City.

She also completes *Jiu Jin Shan* (Old Gold Mountain), an installation of 200,000 fortune cookies at the M. H. De Young Memorial Museum, San Francisco, California.

She learns that her father, whom she hasn't known since infancy, is still alive and living on a rural work farm for elderly inmates near Nanjing, where he had lived for many years. By coincidence she travels there on Father's Day to meet him, and learns that he had been imprisoned on and off since 1948.

1995 Liu serves on the last National Endowment for the Arts Painting Fellowship panel.

She receives tenure from Mills College.

1996 Liu participates in *American Kaleidoscope: Art At The Close Of This Century,* at the National Museum of American Art, Smithsonian Institution, in Washington D.C.

Xia Peng, Liu's father, dies.

Ling Chen goes to college.

Liu turns forty-eight in the "Year of the Rat." Her year. In Chinese mythology, every twelve-year cycle brings a life changing event. At her "Year of the Rat" celebration dinner, Liu reflects upon how her life has changed at twelve-year intervals: how at twelve she moved to Beijing; how at twenty-four the Cultural Revolution ended, she left the countryside, and went to college; how at thirty-six she immigrated to the United States; and how at forty-eight—with her father's death, her son's leaving home, her inclusion in a Tokyo exhibition as an "American" artist, and the beginning of plans by The College of Wooster Art Museum for her ten-year survey—she can finally look back in amazement.

Born

1948 Hung Liu born February 17, 1948
Changchun, China

Degrees

1986 M.F.A., Visual Arts,
University of California,
San Diego

1981 Graduate Student (M.F.A. Equivalent),
Mural Painting, Central Academy of Fine Arts,
Beijing, China

1975 B.F.A., Education,
Beijing Teachers College,
Beijing, China

Academic Positions

1995- Associate Professor of Art,
present Mills College,
Oakland, California

1990-95 Assistant Professor of Art,
Mills College,
Oakland, California

1989-90 Assistant Professor of Art,
University of North Texas,
Denton, Texas

1987 Adjunct Professor, Chinese Art History,
University of Texas,
Arlington, Texas

1981-84 Professor of Art,
Central Academy of Fine Arts,
Beijing, China

Awards and Honors

1996 San Francisco Women's Center
Humanities Award,
San Francisco, California

1994 International Association of Art Critics Award
(U.S. section) for best show of the 1993-94
season by an emerging artist for the
exhibition *Jiu Jin Shan: Old Gold Mountain,*
M.H. De Young Memorial Museum,
Golden Gate Park,
San Francisco, California

1993 The Fleishhacker Foundation Eureka Fellowship,
San Francisco, California

1992 Society for the Encouragement of
Contemporary Art (SECA),
San Francisco, California

1991 National Endowment for the Arts,
Painting Fellowship,
Washington, D.C.

1989 National Endowment for the Arts,
Painting Fellowship,
Washington, D.C.

Public Commissions, Special Projects

1996 *The Long Wharf,* One Embarcadero Center,
41st floor,
San Francisco, California

1995 *Fortune Cookie,* San Jose Museum of Art and
the City of San Jose, California

1992 *Map No. 33,* Moscone Convention Center,
Esplanade Ballroom Lobby,
San Francisco, California

1988 *Reading Room,* Capp Street Project at the
community room of "Chinese for Affirmative
Action," Kuo Building, Chinatown,
San Francisco, California

1986 *Up and Tao,* Media Center and
Communications Building,
University of California,
San Diego, California

1981 *The Music of the Great Earth,*
Foreign Students Dining Hall,
Central Academy of Fine Arts,
Beijing, China

Selected One-Person Exhibitions

1998-2000 *Hung Liu: A Ten-Year Survey 1988-1998,*
- The College of Wooster Art Museum,
 Wooster, Ohio;
- Muscarelle Museum of Art,
 College of William and Mary,
 Williamsburg, Virginia;
- Kemper Museum of Contemporary Art
 Kansas City, Missouri;
- University Art Gallery,
 University of California,
 San Diego, California;
- Bowdoin College Museum of Art,
 Bowdoin, Maine;
- Ackland Art Museum,
 The University of North Carolina at Chapel Hill
 (traveling exhibition and catalogue)

1997 *Hung Liu: New Paintings,*
Steinbaum Krauss Gallery,
New York, New York

*Hung Liu: Unfolding Memory*Picturing History,*
Center for Curatorial Studies Museum,
Bard College,
Annandale-on-Hudson, New York

1996 *Feudal Remnants,*
Rena Bransten Gallery,
San Francisco, California

Focus: Hung Liu,
Fort Wayne Museum of Art,
Fort Wayne, Indiana

Hung Liu: You Can't Go Home Again,
University of Nevada,
Donna Beam Fine Art Gallery,
Las Vegas, Nevada

1995 *The Last Dynasty,*
Steinbaum Krauss Gallery,
New York, New York

Hung Liu,
The Chrysler Museum of Art,
Norfolk, Virginia and
Mills College Art Gallery,
Oakland, California (exhibition brochure)

Can-ton: The Baltimore Series,
The Contemporary,
Baltimore, Maryland (exhibition brochure)

1994 *The Year of the Dog,*
Steinbaum Krauss Gallery,
New York, New York (catalogue)

Tales of Chinese Women,
John Michael Kohler Arts Center,
Sheboygan, Wisconsin (exhibition brochure)

Jiu Jin Shan: Old Gold Mountain, installation,
M.H. De Young Memorial Museum,
Golden Gate Park,
San Francisco, California (exhibition brochure)

Hung Liu: Paintings and Installation,
Fine Arts Gallery,
University of California, Irvine

1993 *Hung Liu: New Work,*
Rena Bransten Gallery,
San Francisco, California

1992 *Sittings,*
Bernice Steinbaum Gallery,
New York, New York

1991 *Bad Women,*
Rena Bransten Gallery,
San Francisco, California

1990 *Trauma,*
Diverseworks,
Houston, Texas

1989 *Goddesses of Love and Liberty,*
Nahan Contemporary,
New York, New York

Chinese Pieta, mixed-media installation,
The Women's Building,
Los Angeles, California

Trauma, mixed-media installation,
Sushi Gallery,
San Diego, California

Where is Mao?,
Brown-Lupton Gallery,
Texas Christian University,
Fort Worth, Texas

1988　*Where is Mao?,*
Southwestern College Art Gallery,
Chula Vista, California

Resident Alien,
Capp Street Project,
Monadnock Building,
San Francisco, California

Reading Room,
Capp Street Project,
Kuo Building,
San Francisco, California

1986　*Canto,*
Annex Gallery,
University of California,
San Diego, California

1985　*Grotto Variations,*
Sheppard Fine Arts Gallery,
University of Nevada,
Reno, Nevada

1981　Central Academy of Fine Arts,
Beijing, China

Selected Group Exhibitions

1997-98　*American Stories-Amidst Displacement
and Transformation,*
· Setagaya Art Museum,
Tokyo, Japan;
· Chiba City Museum of Art,
Chiba, Japan;
· Fukui Fine Arts Museum,
Fukui, Japan;
· Kurashiki City Museum of Art,
Kurashiki, Japan;
· Atorion, Akita Prefectural Cultural Hall,
Akita, Japan (traveling exhibition and
catalogue)

1997　*On the Rim,*
TransAmerica Building,
San Francisco, California

*Traditions/Innovations: Four Northern
California Artists,*
Crocker Art Museum,
Sacramento, California

Fort Wayne Museum of Art: Purchase Show,
Fort Wayne, Indiana

1996　*American Kaleidoscope: Art at the Close of
This Century,*
The National Museum of American Art,
Smithsonian Institution,
Washington, D.C. (catalogue)

Gender, Beyond Memory,
Tokyo Metropolitan Museum of Photography,
Tokyo, Japan (catalogue)

Excavating Culture,
Brattleboro Museum and Art Center,
Brattleboro, Vermont

1995　*Reinventing the Emblem: Contemporary
Artists Recreate a Renaissance Idea,*
Yale University Art Gallery,
New Haven, Connecticut (catalogue)

Making Faces: American Portraits,
The Hudson River Museum of Westchester,
New York

About Faces,
Santa Barbara Museum of Art,
Santa Barbara, California

The Public Art of Re-Collection,
San Jose Cultural Affairs,
San Jose, California

*Dis-Oriented: Shifting Identities of Asian
Women in America,*
Steinbaum Krauss Gallery,
New York, New York and
The Henry Street Settlement,
New York, New York (catalogue)

1994　*Memories of Childhood: so we're
not the Cleavers or the Brady Bunch,*
Steinbaum Krauss Gallery,
New York, New York (traveling exhibition
and catalogue)

*Asia/America: Identities in Contemporary
Asian American Art,*
Asia Society Galleries,
New York, New York (traveling exhibition and
catalogue)

New Voices 1994,
Allen Memorial Art Museum,
Oberlin College,
Oberlin, Ohio

Identities in Contemporary Asian American Art,
Tacoma Art Museum,
Tacoma, Washington

1993 *The 43rd Biennial Exhibition of Contemporary Painting,*
The Corcoran Gallery of Art,
Washington, D.C. (catalogue)

Picasso to Christo: The Evolution of a Collection,
Santa Barbara Museum of Art,
Santa Barbara, California

Narratives of Loss: The Displaced Body,
University of Wisconsin,
Milwaukee, Art Museum (catalogue)

In Transit,
The New Museum of Contemporary Art,
New York

Backtalk,
Santa Barbara Contemporary Arts Forum,
Santa Barbara, California (catalogue)

Twelve Bay Area Painters: The Eureka Fellowship Winners,
San Jose Museum of Art,
San Jose, California

1992 *In Plural America: Contemporary Journeys, Voices and Identities,*
Hudson River Museum,
Yonkers, New York (catalogue)

SECA Art Award 1992,
San Francisco Museum of Modern Art,
California (catalogue)

Counterweight: Alienation, Assimilation, Resistance,
Santa Barbara Contemporary Arts Forum,
Santa Barbara, California

Virgin Territories,
Long Beach Museum of Art,
Long Beach, California

Social Figuration,
San Diego State University Art Gallery,
San Diego, California

Decoding Gender,
School 33 Art Center,
Baltimore, Maryland

Members Gallery: Invitational,
Albright-Knox Art Gallery,
Buffalo, New York

Why Painting-Part I,
Susan Cummins Gallery,
Mill Valley, California

1991 *Counter Colón-Ialismo,*
Centro Cultural de la Raza,
San Diego, California (traveling exhibition and catalogue)

Mito y Magia en America: los Ochenta,
Museo de Arte Contemporaneo de Monterrey,
Monterrey, Mexico

Diverse Directions,
TransAmerica Pyramid,
San Francisco, California

Viewpoints: Eight Installations,
Richmond Art Center,
Richmond, California

1990 *Official Language,*
Walter McBean Gallery,
San Francisco Art Institute,
San Francisco, California

Precarious Links: Emily Jennings, Hung Liu, and Celia Munoz,
San Antonio Museum of Art,
Lawndale Art and Performance Center,
Houston, Texas (catalogue)

No Trends,
Nahan Contemporary Gallery,
New York, New York

Memory/Reality,
Ceres Gallery,
New York, New York

1987 *Art in the Metroplex,*
 Texas Christian University,
 Fort Worth, Texas

 UTA Faculty: New Work,
 UTA Center for Research in Contemporary Art,
 University of Texas,
 Arlington, Texas

 Texas Sculpture Symposium,
 San Antonio, Texas

1980 *National Fine Arts Colleges Exhibition*

1979 *Graduate Student Works,*
 Central Academy of Fine Arts Gallery,
 Central Academy of Fine Arts,
 Beijing, China

1978 *Portraiture Exhibition,*
 Winter Palace Gallery,
 Beijing, China

Selected Public Collections

AT&T Corporation

Baruch College,
William and Anita Newman Library,
City University of New York

City of San Francisco, California

City of San Jose, California

Dallas Museum of Art, Dallas, Texas

Fort Wayne Museum of Art,
Fort Wayne, Indiana

Interra Financial,
Minneapolis, Minnesota

Kemper Museum of Contemporary Art,
Kansas City, Missouri

Mills College,
Oakland, California

Muscarelle Museum of Art,
College of William and Mary,
Williamsburg, Virginia

National Museum of American Art,
Smithsonian Institution,
Washington, D.C.

Rutgers Archives for Printmaking Studios at
the Jane Voorhees Zimmerli Art Museum,
New Brunswick, New Jersey

San Jose Museum of Art,
San Jose, California

Santa Barbara Museum of Art,
Santa Barbara, California

Spencer Museum of Art,
University of Kansas,
Lawrence, Kansas

The St. Paul Companies,
St. Paul, Minnesota

University of Arizona, Art Museum,
Tucson, Arizona

Selected Reviews and Articles

1997 Walker, Bill. "Filling Williamsburg's Art Gap."
 William and Mary News 36 (Williamsburg,
 Virginia).

1996 Allen, Sarah. "Arts Biographic-Hung Liu." *The
 Oakland Tribune,* 13 February 1996.

 Arieff, Allison. "Cultural Collisions: Identity
 and History in the Work of Hung Liu."
 Women's Art Journal 17 (Spring/Summer
 1996): 35-40.

 Atkins, Robert. "Picasso: Love Him? Hate? A
 Bit of Both?" *New York Times,* 29 April 1996,
 42, 46.

 Burton, Jonathan. "Shaking Off the Chains of
 Despair." *Asia Times,* 2 August 1996, 11.

 Crowley, Matthew. "Sensibilities, Identities
 Mix in 'You Can't Go Home Again.'" *Las Vegas
 Review-Journal,* 6 November 1996, 18(AA).

 Dickensheets, Scott. "No Mao-China Girl."
 Las Vegas Sun, 11-13 October 1996, 1(C)-4(C).

 Eckert, Ginger. "American Kaleidoscope:
 Themes and Perspectives in Recent Art, Open
 House." *Washington City Paper,*
 4 October 1996.

 Hemp, Christina. "Critical Reflections." *THE
 Magazine* (Santa Fe, New Mexico) (May
 1996): 49.

Holmes, Anne. "Hung Liu: The Aesthetics of Women's History." *Women's Studies* (Mills College, Oakland, California) (Spring 1996).

"Hung Liu Transforms History into Art." *Artcetera: Regional Art Magazine of the Walton Arts Center Council, Arkansas* 8 (February 1996): 2.

Jones, Joyce. "American Art Through a Prism." *The Washington Post,* 11 October 1996, 55.

Kim, Elaine. "Bad Women: Asian American Visual Artists Hanh Thi Pham, Hung Liu, and Yong Soon Min." *Feminist Studies Inc.* 22 (Fall 1996).

Lewis, Jo Ann. "Kaleidoscope 'Pieces of a Dream.'" *The Washington Post,* 10 October 1996, 1(D) and 8(D).

Roche, Harry. "Hung Liu." *Guardian* 30 (San Francisco), 14 February 1996.

Shaw-Eagle, Joanna. "'Kaleidoscope' Full of Passion." *Washington Times-Metropolitan Times,* 9 October 1996, 9(C).

Smith, Megan. "Excavating Culture." *Art New England* (December 1996/January 1997): 47.

Yang, Alice. "Disorienting Territories." *Art and Asia Pacific* 3 (1996).

1995
Annas, Teresa. "Translating Loss." *The Virginian-Pilot,* 8 November 1995, 1-3(E).

"Art World, Awards." *Art in America* 83 (May 1995): 134.

Corrin, Lisa. "The Dualist." *World Art Magazine* 3 (1995): 36-40.

Dorsey, John. "'Can-ton' Exhibit Extends to Portraits at the Peale." *The Sun* (Baltimore, Maryland), 26 March 1995.

"Hung Liu Exhibit Brings a Piece of China to Canton." *The Contemporary Times* (Baltimore, Maryland) (Summer 1995).

Poshyananda, Apinan. "Yellow Face, White Gaze." *Art and Asia Pacific* 2 (January 1995).

Raynor, Vivien. "Making Faces, Fun, and Pedagogy at Hudson River Museum." *The New York Times,* 26 February 1995.

Tomii, Reiko. *The Shinbijutsu Shinbun* 11/11 (The Japan Art News) (November 1995).

1994
Bitar, Harriet. "Artist Creates Messages Through Her Work." *The Herald* (Plainville, Connecticut), 18 March 1994.

Bonetti, David. "Asian American Artists Take the San Francisco Spotlight." *San Francisco Examiner,* 10 June 1994, 12(D).

Cheng, Scarlet. "The Asia Society Goes Contemporary." *Asia Art News* 4 (January/February 1994).

Cohen, Joan Lebold. "Asia/America: Identities in Contemporary Asian American Art." *Orientations* (July 1994).

Couture, Andrea M. "Visions of Asian America." *Transpacific* (June 1994).

Curtis, Cathy. "Hung Liu's Fortunes Rest in Fresh Paintings." *Los Angeles Times,* 11 October 1994, 2(F).

Dalkey, Victoria. "Poignant and Witty View of Immigration." *Modesto Bee,* 3 July 1994.

Edelman, Robert G. "Report From Washington, D.C.–The Figure Returns." *Art in America* 82 (March 1994).

Jan, Alfred. "Hung Liu." *The New Art Examiner* 21 (April 1994).

Kutner, Janet. "Clash of Two Different Worlds Emerges in New York Exhibit." *Dallas Morning News,* 22 May 1994.

Larson, Kay. "Asia Minor." *New York Magazine* 27 (7 March 1994).

Nash, Steven A. "Jiu Jin Shan: Old Gold Mountain." *Triptych* 69, M.H. De Young Memorial Museum (April-June 1994).

"New Voices 1994." *AMAM News* 5, Allen Memorial Art Museum (Oberlin College) (Spring/Winter 1994).

Porges, Maria. *Sculpture* (November-December, 1994).

Robinson, Hilary. "New York, New York: The Big Apple is Still on Top." *Women's Art Magazine* 58, London (May/June, 1994).

Seto, Doug. "Conceptual Exhibit Is Inspired By a Story of Hardship and Struggle." *Asian Week* (San Francisco), 10 June 1994.

Thym, Jolene. "Oakland Artist Hung Liu Makes a Mountain Out of Fortune Cookies and the American Dream." *The Oakland Tribune,* 13 June 1994, (C).

Utter, Douglas. "New Voices." *The New Art Examiner* (November 1994): 48-49.

1993 Antenorcruz, Maria. "Hung Liu: Year of the Dog." *Asian American Arts Dialogue* 3 (Winter 1993).

Baker, Kenneth. "Contemporary Painting Celebrated in D.C." *San Francisco Chronicle,* 7 November 1993.

"Fleishhacker Names Fellowships." *San Francisco Examiner,* 29 January 1993.

Zimmer, William. "Artists Turn the Brush on Themselves." *The New York Times,* 23 May 1993, (NJ).

1992 Baker, Kenneth. "Mining the Environment for Local Riches—Area Artists Gain Recognition with SFMOMA's SECA Awards." *San Francisco Chronicle,* 27 September 1992.

Bonetti, David. "Lament for Local Artists." *San Francisco Examiner,* 30 October 1992.

Curtis, Cathy. "American Made." *Los Angeles Times,* 8 October 1992.

Graves, Donna and Lydia Matthews. "Evacuations Through Community History." *Artweek* (20 August 1992).

Levin, Kim. "Voice Choices." *Village Voice,* 23 June 1992.

Reed, Victoria. "Two Shows With Messages." *Los Angeles Times,* 29 April 1992.

Santa Barbara Contemporary Arts Forum (Fall 1992).

Watten, Barrett. "Cultural Strategists: 1992 SECA Art Award at SFMOMA." *Artweek* (5 November 1992).

1991 Baker, Kenneth. "A Proper Women's Show at TransAmerica." *San Francisco Chronicle,* 11 May 1991.

Bonetti, David. "Shades of Misogyny, Fascism." *San Francisco Examiner,* 22 November 1991.

Cembalest, Robin. "Goodbye, Columbus." *Art News* (October 1991).

Machida, Margo. "(re) Orienting." *Harbour* (August-October 1991).

Smith, Irvin. "Disparate: Seven Workers." *Artweek* (25 April 1991).

Thomas, Sherry Lee. "A World of Difference." *Artweek* (9 May 1991).

Watten, Barrett. "The Powers of Imbalance." *Artweek* (28 November 1991).

1990 Bonetti, David. "Artists Explore 'Otherness.'" *San Francisco Examiner,* 2 November 1990, 2(C).

Ennis, Michael. "The Ties that Bind." *Texas Monthly* (September 1990).

"Galleries-SoHo." *The New Yorker* (1 January 1990).

Rapko, John. "Modes of Seeing." *Artweek* (8 November 1990).

Roche, Harry. "Global Disconnection." *Artweek* (8 November 1990).

Smith, Rebecca. "Art Beyond the Borders." *The Tribune* (Oakland, California), 27 December 1990.

Yau, John. "Hung Liu at Nahan Contemporary." *Artforum* (March 1990).

Zinsser, John. "Hung Liu at Nahan Contemporary." *Art in America* (June 1990).

1989 Atkins, Robert. "New This Week—Hung Liu." *7 Days* (27 December 1989).

Brew, Kathy. "Hung Liu, 'Reading Room,' 'Resident Alien.'" *Artcoast* (January 1989): 105-106.

Frank, Peter. "Viewing Chinatown: Crossing Cultural Boundaries." *L.A. Weekly* (27 October 1989).

Freudenheim, Susan. "The Art of Protest." *The Tribune*, 13 September 1989.

Geer, Susan. "The Awareness of Being American." *Artweek* (21 October 1989).

Levin, Kim. "Critics' Choice." *The Village Voice*, 19 December 1989.

Ollman, Leah. "Paintings, Text, Speak of the 'Trauma' in China's Body Politic." *Los Angeles Times*, 15 September 1989.

Pincus, Robert L. "Artist's Exhibit Puts Recent Chinese Events in Historical Context." *The San Diego Union*, 14 September 1989.

Raven, Arlene. "Pressure Points." *The Village Voice*, 19 December 1989.

1988 Baker, Kenneth. "Capp Street Wonders Go Public." *San Francisco Chronicle*, 13 September 1988, 2(E).

Berkson, Bill. "Hung Liu, Capp Street Project." *Artforum* (December 1988): 129.

Drewes, Caroline. "The Great Wall of Wong." *San Francisco Examiner*, 30 October 1988, 5(E).

Tamblyn, Christine. "Hung Liu: 'Reading Room,' 'Resident Alien.'" *High Performance* 44 (Winter 1988): 81.

1986 Sewell, Carol. "A Great Wall." *Fort Worth Star Telegram*, 4 April 1986.

1985 Macias, Sandra. "Cave Art." *Reno Gazette-Journal*, 8 December 1985.

McDonald, Robert. "Two Installations of Public Art." *Los Angeles Times, San Diego Edition*, 30 May 1985.

Selected Catalogues, Brochures, Books

1998 Zurko, Kathleen McManus, ed., et al. *Hung Liu: A Ten-Year Survey 1988-1998*. Wooster, Ohio: The College of Wooster Art Museum, 1998 (exhibition catalogue).

1997 Kim, Elaine H., Lilia V. Villanueva, and Asian Women United of California, eds. *Making More Waves: New Writing By Asian American Women*. Boston, Massachusetts: Beacon Press, 1997.

Remer, Abby. *Pioneering Spirits: The Lives and Times of Remarkable Women Artists in Western History*. Worcester, Massachusetts: Davis Publications, 1997.

Sayre, Henry M. *A World of Art*. 2d ed. New York: Prentice-Hall Inc., Simon & Schuster, 1997.

1996 *Gender, Beyond Memory: The Works of Contemporary Women Artists*. Tokyo: Tokyo Metropolitan Museum of Photography, 1996 (exhibition catalogue).

Lumpkin, Libby. "Hung Liu–You Can't Go Home Again." Las Vegas: University of Nevada, Donna Beam Fine Art Gallery, 1996 (exhibition brochure).

Serwer, Jacquelyn Days, Jonathan P. Binstock, et al. *American Kaleidoscope: Themes and Perspectives in Recent Art*. Washington, D.C.: The National Museum of American Art, Smithsonian Institution, 1996 (exhibition catalogue).

Stein, Judith. "Excavating Culture." Brattleboro, Vermont: Brattleboro Museum and Art Center, 1996 (exhibition brochure).

1995 Clark, Trinkett. "Hung Liu." Norfolk, Virginia: Chrysler Museum of Art, 1995 (exhibition brochure).

Corrin, Lisa G. "Hung Liu's Can-ton: The Baltimore Series 'In Search of Miss Sallie Chu.'" Baltimore, Maryland: The Contemporary, 1995 (exhibition brochure).

Leader, Allison B. *Reinventing the Emblem: Contemporary Artists Recreate a Renaissance Idea*. New Haven, Connecticut: Yale University Art Gallery, 1995 (exhibition catalogue).

Lippard, Lucy R. *The Pink Glass Swan: Selected Feminist Essays on Art*. New York: New Press, 1995.

Machida, Margo. *(dis) Oriented: Shifting Identities of Asian Women in America*. New York: Henry Street Settlement Abrons Art Center and Steinbaum Krauss Gallery, 1995 (exhibition catalogue).

Making Faces: American Portraits. Westchester, New York: The Hudson River Museum, 1995 (exhibition brochure).

1994 Atkins, Robert, Roslyn Bernstein, Eleanor Heartney, and Philip Verre. *Hung Liu: The Year of the Dog 1994*. New York: Steinbaum Krauss Gallery, 1994 (exhibition catalogue).

"Hung Liu: Tales of Chinese Women." Sheboygan, Wisconsin: John Michael Kohler Arts Center, 1994 (exhibition brochure).

Nash, Steven A. "Jiu Jin Shan: Old Gold Mountain, An Installation by Hung Liu." San Francisco: M.H. De Young Memorial Museum, 1994 (exhibition brochure).

Steinbaum, Bernice, Judith Rovenger, and Roslyn Bernstein. *Memories of Childhood: so we're not the Cleaver's or the Brady Bunch*. New York: Steinbaum Krauss Gallery, 1994 (exhibition catalogue).

Tchen, John Kuo Wei, Vishakha N. Desai, and Margo Machida. *Asia/America: Identities in Contemporary Asian American Art*. New York: Asia Society Galleries and New Press, 1994 (exhibition catalogue).

1993 Atkinson, Karen, et al. *Backtalk*. Santa Barbara: Santa Barbara Contemporary Arts Forum, 1993 (exhibition catalogue).

French, Christopher C., ed., Maia Damianovic, and Terrie Sultan. *43rd Biennial Exhibition of Contemporary American Painting*. Washington, D.C.: The Corcoran Gallery of Art, 1993 (exhibition catalogue).

Kuspit, Donald. *Hung Liu*. San Francisco: Rena Bransten Gallery, 1993 (exhibition catalogue).

Narratives of Loss: The Displaced Body. Milwaukee: University of Wisconsin Art Museum, 1993 (exhibition catalogue).

Picasso to Christo: The Evolution of a Collection. Santa Barbara: Santa Barbara Museum of Art, 1993 (exhibition catalogue).

Self Portrait: The Changing Self. Summit, New Jersey: New Jersey Center for Visual Arts, 1993 (exhibition catalogue).

Turner, Caroline, ed. *Tradition and Change: Contemporary Art of Asia and the Pacific*. Brisbane, Australia: University of Queensland Press, 1993.

1992 Cervantes, Miguel and Charles Merewether. *Mito y Magia en America: los Ochenta*. Monterrey, Mexico: Museo de Arte Contemporaneo, 1991 (exhibition catalogue).

Chàvez, Patricio, Liz Lerma, and Sylvia Orozco. *Counter Colón-lalismo*. San Diego: Centro Cultural de la Raza, 1992 (exhibition catalogue).

Hale, Sondra and Joan Hugo. *Counterweight: Alienation, Assimilation, Resistance*. Santa Barbara, California: Santa Barbara Contemporary Arts Forum, 1992 (exhibition catalogue).

In Plural America–Contemporary Journeys, Voices and Identities. Yonkers, New York: Hudson River Museum, 1992 (exhibition catalogue).

SECA Art Award 1992: Hung Liu, John Beech, Maria Porges. San Francisco, California: San Francisco Museum of Modern Art, 1992.

1990 Edwards, Jim. *Precarious Links: Emily Jennings, Hung Liu, and Celia Munoz*. San Antonio: San Antonio Museum of Art, 1990 (exhibition catalogue).

Lucy L. Lippard. *Mixed Blessings: New Art in a Multicultural America*. New York: Pantheon Books, 1990.

1988 *Capp Street Project: 1987-1988*. San Francisco, California: The Capp Street Project, 1988.

Videotape

1996 Liu, Hung. *Hung Liu: Works in Progress*. Henry Sayre, the Oregon Public Broadcasting Company, and The Annenberg/CPB Project, 25 minutes, for *A World of Art*, 1996. Videocassette.

**NATIONAL
ENDOWMENT
FOR THE ARTS**

This exhibition, catalogue, and traveling exhibition were made possible by support from the National Endowment for the Arts and the Ohio Arts Council.

The Ohio Arts Council helped fund this organization with state tax dollars to encourage economic growth, educational excellence and cultural enrichment for all Ohioans.